BONDAGE

for

Sex

VOLUME 1

BONDAGE

for
Sex

VOLUME 1

CHANTA
ROSE

BDSM
Press

For further information, please contact:

BDSM Press
336 Scott St
San Francisco, CA, 94117
enquiry@bdsmpress.net

Book design by:

ARBOR BOOKS, INC.
19 Spear Road, Suite 202
Ramsey, NJ 07446
www.arborbooks.com

Printed in Canada

Library of Congress Control Number: 2006900040
ISBN: 0-9777238-0-1

I would like to dedicate this book to those who have
influenced me most on my journey as a rigger:

Marty
Peter
PD
The Bound Jewels collection of photos

Your work continues to inspire me.

Disclaimer

The author and publisher assume no responsibility whatsoever for any loss, injury or damage resulting from the ideas in this publication, from the bondage positions displayed, caused by any inaccuracies, omissions or inconsistencies in this publication, or for the reader's failure to follow instructions. Further, the author and publisher assume no responsibility whatsoever for any injury or damages resulting from the use of rope or other bondage materials or from the positions displayed in this publication.

The bondage, sex and BDSM play in this book are intended for consenting adults. The use of bondage, BDSM and sex toys may be dangerous if proper caution and prudence are not exercised. Before beginning any bondage activity, read all instructions thoroughly and follow all safety precautions necessary for safe and proper play, including discussing any medical problems parties involved may have.

The use of drugs and alcohol can seriously impair judgment and increase risk.

Contents

Foreword

I believe bondage is all about sex. Over the years I have heard many explanations as to why more and more people are showing an interest in BDSM. Are we, as a society suddenly obsessed with pain? Is it because Hollywood is producing more controversial films, often containing a scene or two depicting (bad) bondage? Maybe it is because our culture focuses so much on control and power that people desire to recreate these feelings during the most intimate of acts. The questions are endless and the numerous answers are fascinating, but none of them apply to this book and why it has been written. This book is about bondage that can be used for any type of sexual activity, be it vaginal, anal, oral or whatever else you may think of. You do not have to be submissive by nature to enjoy being bound for sex. I am naturally dominant. I have no interest in being a good, obedient slave, but I do love to be tied up and forced to cum time and time again! It is a selfish pleasure, and not one that can be assumed to be submissive just because I am bound.

I love bondage: tight, safe, inescapable bondage. When I am bound, my body expects to have sex. Bondage almost doesn't feel complete to me without it. Of course, this is not the case for all BDSM enthusiasts. I know many couples who use bondage only as a form of foreplay or just for oral sex. In community dungeons and play spaces there may be no sex at all. There is no right or wrong in SM or bondage play, but I have long wondered why the rope (all of it) is often removed for the finale of intercourse, should the play ever even reach that point. Is it because the couple prefers to have sex without bondage? Or is it because the bondage is not comfortable/accessible enough for sex? Perhaps the bottom has been restrained for quite some time (throughout flogging, foreplay, etc.) and simply cannot maintain the position any longer and must be released. Many BDSM enthusiasts I have asked said they wished they could include more bondage in their sex lives but just didn't know how to tie rope and would opt for leather cuffs as restraints instead. As wonderful

as cuffs are for basic bondage, they are very limiting and, in time, will become boring. With some basic knowledge, the possibilities available with rope bondage are endless. That is why I felt this book needed to be written—not necessarily just for players in the BDSM community, but also for monogamous couples in small towns who may want to experiment but don't know where to begin.

It was decades ago that I would come home from school and set up to play with my dolls. I thought I was just like every other girl when I would take twine from the kitchen and tie up Barbie. My favorite dolls were the ones that allowed you to bend all of their limbs; after all, they were the most flexible. More than once I played out interrogation scenarios where I would have my dolls stripped, bound and blindfolded awaiting orders from my Ken. Even though I did not realize it at the time, this was the very beginning of my love for bondage and role-play.

As a teenager I took to carrying handcuffs with me everywhere. I would try to convince my friends (male and female) to let me cuff them to inanimate objects like lampposts. At the stables where I worked, the other teens were more open-minded. We would take turns hitting each other with riding crops to see how much pain we could take. I was intrigued by the sensation and sexually aroused. Rope, leather and whips surrounded me; it was heaven, although I am not sure that even at that point in my life I understood why.

As a glamour model in my early twenties, I was approached about doing some light bondage shoots. I accepted and, in a few short months, found that the majority of my modeling career in the United States and United Kingdom was as a bondage model. I was flexible, could endure difficult positions and would try absolutely anything. I am dominant in my personal life, but there was something about being bound—the challenge, the rush. It was intoxicating! Still, something was missing. On a shoot the model is bound, photographed, perhaps fondled a bit and then released. I needed more... I needed full penetrative sex, and I wanted to be forced to orgasm.

Once I found myself with a partner who would tie me tight and fuck me the way we both desired, it was the end of my career as a bondage model. To be bound and not fucked simply didn't make any sense to me anymore, even for a shoot. I took this philosophy with me when I began managing three of the most successful bondage sites on the Internet. Where there was bondage, there must eventually be sex, and this was always portrayed in the hundreds of shoots I directed. Genuine boy/girl hardcore sex could not be shown while a model was in bondage, so I used my tongue, fingers, vibrators, dildos and anything else I could find. There is no comparable feeling in the world to that of a truly forced orgasm, and it was a pleasure to be the one able to inflict this sensation on so many bondage virgins over the years. It was during this time that I had the opportunity to tie all types of bodies: big, small, male, female, flexible and not.

I would like to explain that I never took bondage lessons of any kind. I am completely self-taught and found very early on that I

had a natural flair. As a bondage model and SM enthusiast, I saw many bondage producers at work and soon discovered who was my personal favorite—Peter Rodgers. I made a point of studying photos of his work on Hogtied, and recreated those ties in shoots of my own. At that time the site also offered a huge gallery of purchased bondage photos from Japan that I adored. From these influences I began to rig, and my style reflected the comfort of Peter's bondage and the beauty of traditional Japanese bondage. My experiences as a bottom had given me a good understanding of what was comfortable and where knots should be placed. Being a model was invaluable to learning how NOT to tie bondage. I sustained more than a couple of injuries as a result of producers being careless in regard to the basic physics of bondage. Placement of pressure and weight distribution are very important in applying safe rope bondage, especially for suspension.

The goal of this book is to teach basic to intermediate bondage techniques that can be applied to a variety of body types for penetrative sex. Most of the positions are unisex and provide adequate access for oral, anal and vaginal sex. I have deliberately chosen positions that, when rigged comfortably, are quite sustainable for the bottom to maintain for extended sex play. Some of the variations are more strenuous and may not allow for as much play time. All of the positions are inescapable and represent what I believe to be good, strict bondage. Remember, this book acts only as a guide; there is no right or wrong in bondage. Just because I use a square knot does not mean that everyone else has to.

By choosing to use a different knot your tie is not "wrong," it is merely different and is probably just as effective. Once you have learnt the basics, I urge you to embrace your bondage creativity and experiment with your play partners. As your confidence builds so will your desire to try new bound sex positions. Remember, always play safe, and enjoy!

So...You Want to Try Kinky Sex?

Sometimes the most difficult part of wanting to have sex that includes bondage or other kinky acts is asking, explaining and perhaps even convincing your partner. It may not matter if you have been with someone for one night or monogamously for ten years, being tied up can be scary. What if you don't like it? What if you want to be untied and your partner refuses? Why does your partner want to tie you up anyway? Does he want to hurt you? These are all very reasonable questions and there is no simple, one-word answer for every couple.

If you would like to introduce bondage into the bedroom, you will need to speak about it with your partner and be ready to answer a lot of questions. This is regardless of whether you wish to be the Top or the bottom. Bring up the topic in an environment non-threatening to either of you, be patient and understanding. This is the kind of subject that could result in any number of reactions, from excitement to nervousness to confu-

sion. For example, if you are a female wishing to be tied up and approach your partner about this, he may think you want to be "abused" and that he could never do that as he was always taught not to hurt women. Of course, being "abused" and being "restrained" are two very different things. For one, abuse is not a consensual act. You will need to explain that you do not wish to be abused or mistreated at all and that you expect to be respected at all times, but you would like to try this because...etc.

If we turn the tables and you have a man who wishes to tie up his female partner, she may not understand and think he wants to cause her pain or hates women. After all, why else would he want to tie them up? Of course, a man may also wish to be bound and has to deal with similar issues. What if his partner finds him "pathetic" because he wants to be tied up? Wanting to partake in submissive acts does not make a person pathetic. If anything, it is empowering. It shows that you

are comfortable enough with your sexuality to want to explore your fantasies.

When approaching your partner about wanting to try bondage sex, keep an open mind, be ready to answer questions and be honest. If you have had bondage fantasies since the age of 7 then say so. If you would like to try bondage sex but are scared, try to figure out why so that your partner can understand. Maybe you just saw a mainstream movie with a light bondage scene and it was arousing to you. Perhaps you are happy to try bondage but you have no interest in any type of punishment. You may also need to explain why you have this fantasy and that it in no way means you hate men or women, or wish to cause them pain in an abusive manner.

It is a common misconception that because people allow themselves to be bound that they must have low self-esteem and that they are not "equal" in the relationship. Any type of bondage or S&M play should be based on equality, mutual respect and trust. Just because someone is the rope Top, it does not make him or her superior to someone who is a rope bottom. This is why talking beforehand is so important. If you have any doubts or fears based on this misconception, it is best to discuss it.

When someone first allows himself to be tied, it is very important for him to have a good experience. Even if it is a short experience that ends in needing to be untied (for any number of reasons), it should still be positive, without pressure or disappointment. When it comes to bondage, once bitten, twice shy can easily apply. It is okay to want to take things slowly. It is okay to only be partially bound initially until you feel more comfortable taking things a step further. It is also okay to realize that bondage just isn't your thing. Not all sex acts are for everyone, so why should bondage sex be any different?

Sex should never feel uncomfortable (mentally) or forced. There shouldn't be any "peer pressure" where sex is concerned. If bondage is something you simply do not want to try then you don't have to. Bondage sex, in particular, requires a lot of trust and responsibility from both parties. If you enjoy it, that is the price you pay for the mind-blowing orgasms you will have! If you don't enjoy it, or are simply not ready as a couple for whatever reason to try bondage sex, put the rope away and do what does feel comfortable to you. You may wish to try an alternative restraint if rope is intimidating to you at first; I recommend leather cuffs or silk scarves. Always remember: no pressure. I recommend http://www.agentsm.com for silk scarves and http://www.extremerestraints.com for a good selection of leather cuffs and other restraints.

Thankfully, kink has come a long way in the past few decades and resources are available in abundance to help answer any questions you may have that I have not addressed. A simple Google search for "introduction BDSM" will bring up all kinds of online, print and regional resources. Other great bondage-specific books include Jay Wiseman's *Erotic Bondage Handbook* and Midori's *The Seductive Art of Japanese Bondage*.

If you're new to Topping, I recommend *The Topping Book*, and if you're new to bottoming, *The Bottoming Book* is also an excellent resource. You will also find many organizations that hold classes, workshops and even play parties all over the world. Just because you want to try bondage does not mean you now need to become a swinger who goes to dungeon play parties, but you can still attend the classes! You don't need to join organizations and play with other people, but if you want to then those resources are available. Being kinky, and where and how you choose to do it, is up to you entirely. I am an ex-porn star, I am monogamous and I allow only that one person to tie me up for sex. This works for me (to many people's surprise), so please, do what works for you.

Bondage Styles

There are many "styles" of bondage and, as this is a subject that is not well-documented, I don't believe there is any one authority on the subject as a whole. Everyone will adopt their own style while in the learning process of rigging and may then refer to themselves as a certain type of rigger. This is most easily displayed in Japanese bondage, where at different levels of skill the rigger is given a title. For example, a Nawashi is literally defined as a rope artist. In Japan you must reach a certain proficiency with your rope work to be referred to as a Nawashi.

What you'll find here is <u>my</u> understanding of different styles of bondage. Some Tops like to define themselves by rigging style. I suppose that makes me a hybrid. I am skilled in all of them yet I prefer to mix them up rather than just choose one as my favorite. That is my bondage style.

Western (aka American) Bondage:

Photographer Irving Klaw and artist John Willie can be thanked for much of the style we now refer to as Western or American bondage. In their works, bondage plays a secondary part to the image as a whole. There is a huge emphasis on the stylized look: extreme high heels, tight corsets and hobble skirts all place the female (males are not used in their works) in a form of bondage without any rope at all. When drawings or photos did show rope bondage, it would usually be simple and assist in giving the bottom an even more defined, streamlined look, forcing the body into a contortion much the way the corset and heels did. For example, the bottom's wrists and elbows may be tied behind the back, which would thrust the breasts forward, pull the shoulders back and force the

bottom to stand completely straight. America's love affair with the perfect pin-up girl was clearly a big influence in creating this imagery. Western bondage has always been portrayed as symmetrical and rarely lends itself to sex. Limbs are usually tied together (wrists, elbows, ankles, knees) and there is very little use of elaborate rope harnesses. Although Irving Klaw used rope in his banned (and many burned) photos of Bettie Page, John Willie does not restrict his artwork to just rope bondage. Pictures include black leather sleeves, cuffs and even chains that complement the corsets and heels to complete the entire package. The bondage may be simple, but it is "real" bondage, always strict and inescapable.

Japanese Bondage (aka Shibari):

The most artistic of all bondage styles, and arguably the most beautiful, involves using rope patterns that originated in Japan. The art of Japanese bondage is not necessarily in the knowledge of these patterns or how to tie the positions, but rather in creating a feeling of freedom and beauty within the ropes. In Japanese bondage an emphasis is placed on how the rope should be sensually applied to the body of the bottom. The Master will continue to add layers of rope and even take care to place knots on certain erotic pressure points. The positions often include crossed limbs or beautiful harnesses that are wonderful for bondage sex. Crossed legs allow easy access to sex organs, and harnesses make the bottom feel supported by the bondage. It also gives the Top many "grab" points to gain leverage while engaging in intercourse.

Suspension Bondage:

Not so much a "style" as a position type, yet still worthy of mention. More experienced riggers usually venture into partial suspension and then full suspension bondage with their bottom. The bondage can be either Western or Japanese in style, but more often the latter. When suspended, the bottom has a feeling of floating while being fully restrained in the most inescapable of ways. There is a complete helplessness in being suspended that can make the bottom quickly fall into a delightful subspace. For the Top, there is a great feeling of achievement in full suspension and endless possibilities for great sex! In order to become skilled as a suspension rigger, you need to understand the physics of bondage. Knowing the weight-bearing knots and a few basic ties is not enough to safely suspend a bottom, and I always caution beginners about trying suspensions too soon. Learn the basics first and then progress.

Speed Bondage:

This is quite literally what the name suggests and involves tying up your bottom very quickly. My understanding is that it is used mostly in role-play games that involve consenting adults playing out a non-consensual fantasy in which, if the situation were real, the bondage would be applied in a fast manner

(like a kidnapping). As a result, the bondage is not always neat, but that is part of the style in itself. As long as the bondage is tight and inescapable, a few messy knots or ends of rope hanging on the floor just add to the grunginess of the situation, and for many this is a huge turn-on. Personally, I find this to be one of the most difficult styles of rigging, as not only must you be incredibly fast (while still being safe), but more often than not the bottom is struggling to maintain the role of victim being bound against his or her will. It is not easy to tie someone who is struggling and fighting back.

Sex Bondage:

Again, the name says it all. Bondage for sex is literally the tying of the bottom in a position that is accessible for oral, anal and/or vaginal sex. It can be Western, Japanese, suspension, etc., as long as the sex organs are available to be penetrated when the tie is completed. Sex bondage involves placing the bottom in bondage just tight enough to be inescapable and just stressful enough to be strict without making the position unbearable for longer periods of time. There needs to be just enough "give" for the position to be sustainable for the duration of sex and play.

Movie Bondage:

I am sure that it was in some movie, television show or comic book that most people first saw "bondage" and it may have been from that very moment that an interest began. Certainly, the fact that bondage in film/TV almost always shows bondage used as a negative, for an abduction, interrogation or hostage situation, is interesting, as many people like to play these role-play games within the realms of consent. Ironically, once you know how to rig, you will also notice that rope work is usually badly done in any type of mainstream entertainment. Loose ties are not cinched, knots are placed where the "victim" could untie them, thick rope is used that would not effectively hold a knot and any type of gag used is usually in front of the teeth, defeating its entire purpose. I personally put this down to three reasons: a) for legal reasons "real" bondage may not be permitted in mainstream entertainment (fear of censorship or harsher rating); b) the bondage is supposed to be in continuity with some type of frantic activity (like a kidnapping), therefore the bondage should be messy and imperfect; and c) staff members working on the production are not into bondage and, therefore, simply don't think of things like knot placement. I personally hope to see many more movies released in the coming years with bondage scenes included. As the mainstream becomes more aware, perhaps the quality of the rope work will improve.

Porn Bondage:

My specialty. I believe that once someone realizes that bondage is erotic, they will either find someone to try it with or look to porn (for help or masturbatory purposes).

In recent years the amount of bondage pay sites on the World Wide Web has exploded (as with all porn), yet there are still only a handful worth looking at for quality bondage. I have always considered Internet porn to be a fabulous place to get ideas for role-play games or to look at different ways to tie people up. Prior to the Internet I imagine that bondage images were limited to magazines and artwork. The problem with artwork is that most humans cannot bend the way the girl in the drawing can and although bondage porn uses real people, the same problem still exists.

There is something hugely arousing about seeing a hot model tied in a backbreaking arch, or with her elbows together almost all the way up to her shoulders, or perhaps suspended in the splits. I even tied a girl up once who was so flexible she could eat her own pussy! The style of good porn bondage is to show bondage that you simply could not do on the average person and that you will not see anywhere else. If you are fortunate enough to be playing with a contortionist or yoga instructor, then by all means make use of that flexibility, but don't expect it from the average bottom.

However, not all bondage porn is about flexibility and impossible positions. Much of it portrays other fantasies (such as abduction) on a rougher and more pornographic level than mainstream movies can. There is also a huge genre of damsel in distress sites/videos that use only basic Western bondage and try to recapture the artwork of John Willie in moving pictures.

Before You Begin Rigging

Safe, Sane and Consensual Play:

Before the ropes are removed from your bag of goodies, certain limits and guidelines must be established between play partners. For bondage sex to be a mutually rewarding experience, both parties must be aware of what may or may not happen next and how to stop it should one feel uncomfortable for any reason.

A "safe word" should be discussed before any play begins. Many people like to use the "traffic light" method of safe-wording, in which green implies, "Yes, I'm fine. Please continue and increase intensity;" yellow means, "Caution. Slow down;" and red is a very clear and firm, "Stop." Whatever safe word is chosen, it should be very clear to both parties that when it is used it literally means "stop." For this very reason most players do not use the words "no" or "stop" as safe words, as many bottoms will say these as part of role-play games (I know I do). I know one dominatrix who uses the word "burrito" when scening. Her theory is that a word describing a Mexican food is so out of place

in an S&M scene that there is no way it could be confused as anything but a safe word!

If your bottom is to be gagged throughout the scene, he may not be able to say the safe word, so an alternative must be available. In my personal play, and also in bondage shoots, I have always used a very loudly pronounced "uh-uh" sound. It may seem as if this would not be clear to your partner, but in years of rigging I have never missed this very distinctive sound. A safe signal is also an option. For example, the bottom could open and close his hands as a sign to stop. During underwater shoots, I would always have the bottom shake her head from side to side as a safe signal. It always worked but I am not sure that I recommend signals as much as sound. It is a lot easier to miss a signal, so use one only when a safe word simply isn't an option, and remember to keep your eyes on your bottom at all times.

Agreeing on a safe word is not the end of the negotiation. Limits must also be discussed, as well as expectations. What do you hope to get out of the scene? Is that something the bottom is interested in? Are there any hard limits that need to be discussed? Is

there any illness or injury that either of you should know about? I am not trying to kill the passion with lots of questions, but it is the answers to these questions that will lead to a very good time for all involved.

Sanity is not always given as much consideration as it should be. Yes, you may have checked that everything is safe and you also have your play partner's consent, so it's time to tie, right? Wrong. Is your partner "sane" and, to hit even closer to home, are you? I am referring more to the use of mind-altering substances than whether you should see a shrink or not! Before engaging in play with someone, please consider how many drinks you have had, anything you may have smoked or any pills you may have popped. You would not drive a car under the influence, so please don't tie someone up in this state. Once you have established that you are capable of making the sane decision to play, it's time to consider your bottom. The same questions apply. When someone is tied after drinking (in excess), taking muscle relaxants, smoking marijuana, etc., she is less likely to notice numbness and her pain tolerance will be increased. A bottom who is "high" on something other than subspace may not notice warning signs the body is giving to prevent real injury. It is the bottom's responsibility to use her safe word as needed, but as a Top it is your job to constantly monitor your bound beauty. If you feel there is a risk of injury then you may also call the safe word and end the scene and, of course, immediately release the bottom from bondage.

So you've checked that everything is safe and sane and now you really want to get on to the good stuff. Make sure your bottom wants to play (consents), discuss limits (dos and don'ts), and off you go!

Choosing Rope:

The list of materials and types of rope available is extensive, and you can really experiment with anything from twine to washing line cord. But as this book focuses on bondage for sex, I feel that only the most comfortable rope should be considered.

Nylon rope is widely available at hardware stores, supermarkets and kinky places. It is available in many different lengths and you have the choice of twisted or braided. Both are soft and very easy to tie with. As so many lengths are available, you may not even have to cut your own lengths of rope. Braided nylon generally lasts longer than twisted, as it does not unravel as quickly. A good way to "finish" the ends of synthetic rope is to

Flamed Ends

quickly place a flame under the end. The rope will melt and harden, thus stopping it from untwisting. Please check that in the melting process no sharp ends materialize, as this could be very unpleasant for the bottom. I usually tie with nylon that has a 1/4-inch diameter, but have also used 3/8-inch thickness before. Personally, I do not like to tie with rope that is thicker than this, but I do find that a lot of people learning bondage for the very first time feel safer with a thicker diameter rope. This is purely a personal preference, so use what you are comfortable with. Unfortunately, nylon is a very slippery rope, meaning it does not always hold knots well. If I do a reef knot using hemp rope, I would probably do that twice with nylon just to be

sure. Still, it is a great, inexpensive rope to start playing with.

Cotton rope is lovely, soft and also easy to find. Being a natural fiber, its ends cannot be finished with a flame, but there are other options. Taping the ends of your rope with

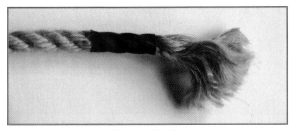
Taped Ends

electrical tape is very effective, or tying a simple overhand knot at the ends will also work. Cotton rope can be easily washed in your machine and will soften with washing. It also has a bit of "spring" to it. Rope that has some elasticity can be nice for the beginning Top and bottom. The bottom will be able to feel a little give in the rope and the Top will not worry so much about tying too tightly. Unfortunately, I have found cotton rope to have a fairly short shelf life. The strength of the rope is not always consistent, so I have never used it for suspension or partial suspension-type bondage. As this book focuses mainly on ties that will occur on a bed, cotton rope is certainly a safe option, but should you decide to move into more weight-bearing positions, it may be time to change rope.

Hemp rope is my absolute favorite, and

Hemp Rope

after years of tying it is all that I will use now.

Unfortunately, it is not as easy to find as nylon and cotton, and is even more rare should you wish to purchase it treated. Treating raw hemp rope is very time-consuming. I know some riggers find the process to be a spiritual experience, but it requires a lot of patience. Instructions on how to treat raw hemp rope are available easily by searching online. Personally, I like my hemp rope to be treated when I receive it, and have found a few wonderful US suppliers that offer lovely twisted and fully treated hemp rope. For up to date information on where to buy quality hemp rope, go to **www.bondageexpert.com**.

The ends of hemp rope cannot be burned. Tying wall knots or using tape is an option, but I prefer my hemp to have "whipped" ends. This is where sewing thread

Whipped Ends

is stitched around the ends multiple times to make a very attractive finish. You can see this in the pictures where I have used red rope. This is a time-consuming practice, but hemp rope is a fairly expensive investment and will last a long time, so it's worth the extra effort. Again, this is a personal preference.

Once you have decided which type of rope to tie with, you will either need to order pre-cut lengths or cut them yourself. I use only 12.5-foot, 25-foot and 50-foot lengths of rope. I often refer to small, medium and long lengths throughout the book. In time you will determine the lengths that you feel comfortable using. Although I am set in my ways with the lengths I use, I usually recommend lengths of 15 feet, 30 feet and 60 feet to be

purchased. This is because the average person is larger than the porn stars I am used to tying up! It is easy to be intimidated by a long length of rope, so I encourage beginners to start with shorter lengths. But it is completely up to you. In rope bondage it is often better to have too much than not enough.

Remember, bondage does not have to be limited to using rope. Leather straps, silk scarves, business ties, cable ties and washing line cord are just a few alternatives. The first time I was tied up for sex, I brought my partner some cheap bed sheets to tear up. To this day, torn-up bed sheets are still my favorite material to be bound in for sex.

Applying Rope to the Body:

Many bondage enthusiasts like to take time applying rope. The process itself can be a very sexy form of foreplay, as you slowly remove all control from your subject. Others would rather just get their partner tied up to move on to sex acts. Whichever is your preference, you need to make sure your rope has not managed to pick up any fibers or tiny sharp objects before applying. Imagine if you were frantically tying your partner only to not realize the rope had picked up a staple from the floor. You then pull the rope over your partner's body and the staple causes a painful open wound. I imagine that would be the end of the sex right there! Thankfully, checking rope is very easy. As you apply each piece of rope, simply run it through your fingers before using it on your partner. You will feel anything sharp that may have lodged itself and will then be able to remove it or use a different piece of rope.

Learning the Knots:

Many bottoms that I have had the pleasure to tie have always commented how complex bondage looks and have wanted to know where I learnt all of the knots. The fact is I only know a few knots and I use them time and time again. They are good, simple and reliable, and there is no reason for someone to be intimidated by bondage because they think it is all about the knots. If you can tie your shoelaces, you'll be just fine.

Here is a basic rundown of the knots I will be using throughout the book:

1. **Overhand Knot:**

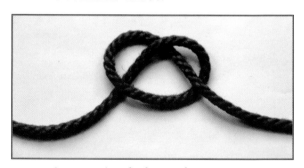

A very simple knot that everyone uses when they begin to tie their shoes

2. **Reef Knot** (also known as a square knot)

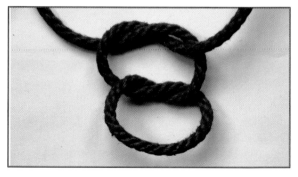

A series of two overhand knots. When done incorrectly, it becomes a granny knot.

20

3. Lark's Head

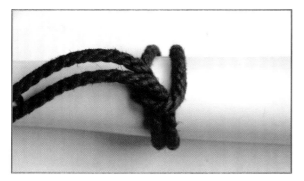

Lark's Head Knot

This knot is used in two different ways in bondage. Firstly, it is the way you will begin most ties. Secondly, it is what you will use to "lock off" the bondage so that a tie cannot get any tighter when tension is applied.

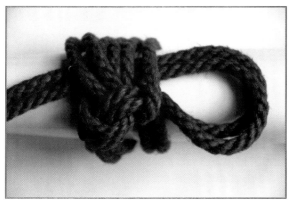

Step 1

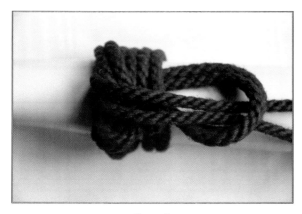

Step 2

Step 3

Terminology Used Throughout:

Here is a basic rundown of the terminology I will use throughout the bondage lessons in this book:

"Play" is broad by any definition. Play could include spanking, flogging, foreplay of any type, sex acts or anything else you may like to do when you are tied up or have your partner tied up. As everyone is different, I have chosen to refer to all acts as *"play."* I have also used the word *"scene"* to describe the time spent *"playing."*

"bottom" is the person being tied.

"Top" is the person doing the tying.

"Find the middle and make a loop" simply refers to folding your length of rope in half. Take the rope around the body part that is to be bound and bring the ends of the rope through the centre loop. This is a basic lark's head knot.

"Create reverse tension" is what usually happens next. You have looped through and now you are going to take the rope back around the body part in the opposite direction.

"Lock off the bondage" is my slang way of saying secure the bondage so that it can't pull tighter when tension is applied. To do this, rope is usually taken under ALL of the binding and a loop is made through which the remaining rope is pulled. This is also a lark's head knot.

"Finish the tie" is clearly very broad. As I mentioned in the knots section, you may use whatever knots you wish, so I prefer to leave that decision to you. I usually finish all bondage ties (on the body and when tying to external structures) with a square knot.

The Bed:

Bondage for sex is not limited to using a bed, but for the sake of comfort this is where my partner and I did most of the testing of the positions! Thankfully, our bed has a lovely headboard with lots of tie points, but I do realize this is not the case for all beds. I have designed a variety of positions: some that need corner tie points, some which need no tie points at all, as well as a few that will work only if you do have a headboard. Of course, if you have a full canopy style bed your options for bondage are endless. You may even be able to do some partial suspensions. Please check that the canopy part of the bed is weight-bearing before trying anything like that. If you are looking for side tie points on your bed, you may have some easy-to-tie-to bed slats under the mattress. If this is not the case, simply tie rope from one bed leg to the other as tightly as you can and then use this rope as your anchor point for any bondage.

A Few Words of Caution:

Injury, slight or major, can occur when tying someone up. I am not a doctor, so I cannot give medical advice, but rather I just draw on my experiences as a rigger and some injuries I incurred as a rope bottom. Here is a short list of some of the most common injuries and how to avoid them:

Rope Burn: If there was ever a passion killer, this is it. Rope burn can occur when pulling rope through limbs (cinching), when removing rope too fast or when applying pressure to rope bondage during play. For example, you are having doggy style sex with your bound bottom and are using the chest harness as a handle to give yourself leverage. This is fine, as that is what it was intended for, BUT you may be causing rope burn on the bottom's shoulders. Once the passion has come to an end, treat rope burn like you would any other burn.

Loss of Circulation: This will usually happen in the hands, but you do need to also watch for it elsewhere. Loss of circulation occurs when rope is putting pressure on various arteries and veins, therefore restricting the flow of blood. The most obvious signs of this are:

- Discoloration of the limb; the area may start to turn a shade of purple/blue.
- Temperature; the limb may start to become cold.

If you tie too tight, you are more likely to cause a loss of circulation, but as a rule everyone's blood pumps differently and even with bondage that is not too strict, you may restrict blood flow. When my hands are tied behind my back they instantly lose color, but I can stay in the tie for quite a long time without any problems. Everyone is different and communication is the key. If you notice discoloration of limbs on your bound partner, be sure to check that everything is okay.

Nerve Damage: Probably the most dreaded injury of all. Nerve damage, in effect, paralyses the limb (or part of) until healed. In rare cases nerve damage can be permanent. The only way I can describe the feeling of nerve damage as it occurs is a very intense, shooting pain that certainly could not be confused as erotic in any way. This pain is

"bad" and should not be ignored. Sometimes there may be no warning given by your body at all. As a rope Top, you have a responsibility to rig safely. This involves knowing where not to place pressure, where not to add weight and how to communicate with your bottom. As a rope bottom, you have a responsibility to know your body, to know when to say stop and to not let things go too far. What do I mean by this? If you cannot move your hands, or if you have no feeling whatsoever in them, you have gone too far. No amount of sex is worth this injury. Play safe.

Other Things to Consider:

So, you've got the rope and the bed, you've learnt the basic knots and your bottom is ready to be tied and made love to. Is there anything else you need? Yes, but don't worry, you're almost there.

A number of items should be readily available in case of emergency, or just for your bottom's comfort:

- Safety scissors (EMT shears). You never know when you may need to cut rope to release a bottom quickly. Rope is cheap, medical bills are not, so don't ever hesitate to cut rope if you absolutely need to.

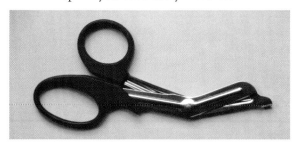

- Water or other drinks. Water really is the best fluid to have around, but juice and other energy drinks, such as Gatorade and Vitamin Water, are also good. A nice touch is to also have a straw for a bound bottom to be able to drink from. It is best to stay away from carbonated beverages or alcohol when in bondage.

- Blanket or shawl. Body temperature can change rapidly during and after a scene.

- Small towels and pillows. If you are playing on a rough/hard surface, either of these items can be placed under areas of discomfort (knees, head, etc.).

- Vibrator! Perhaps Hitachi did design the magic wand to be nothing more than a back massager, but that is not what I use it for. For guaranteed multiple orgasms (for men, too), get a magic wand and bring an extension cord.

- Condoms. Unless in a committed monogamous relationship, please practice safe sex.

- Lubricant. Hey, you may not need it, but it's always nice to have and is a lot more effective than spit! I recommend water-based lubricant for vaginal sex and silicone-based lubricant for anal sex.

- Paper Towels. Damn. All of this kinky bondage sex can get messy!

- First Aid Kit and CPR/First Aid Training. Everyone from all walks of life should be CPR trained, but with this type of activity it is a no-brainer. It only takes a few hours to learn CPR/First Aid from an accredited trainer, so please take the time to get certified. A basic first aid kit is always good to have in case of any scrapes, rope burn or other minor injuries that may need treating.

Okay. Got all of that? Then let's get tying.

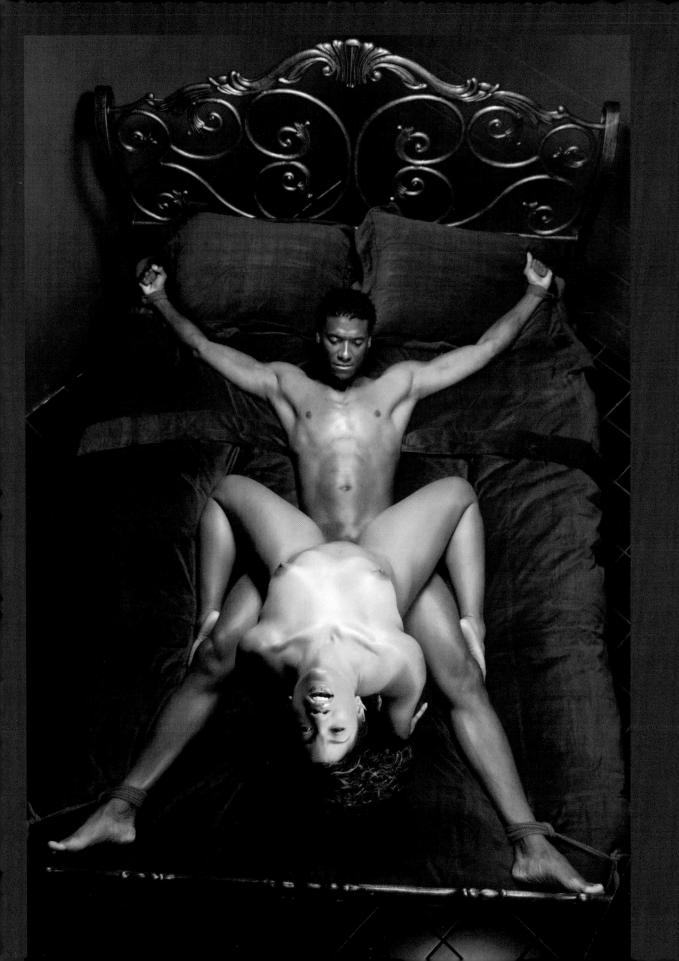

Basic Spread-Eagle

When you think of having sex with bondage, this is probably the first position that comes to mind. If you have already experimented with some light bondage, this is probably the position you have tried, and if you plan on giving bondage sex a try, this is, without a doubt, the easiest tie to start with.

Personally, I find the position limiting for the actual act of sex, but it is wonderful for foreplay and is very comfortable. Once your bottom is bound, you can tease him all over with your tongue or just choose to sit on his face. As far as punishment goes, the bottom is displayed to the Top like a clean canvas, so the possibilities are endless: ice, hot wax, flogging, clamps and forced oral, just to name a few.

Have fun with the spread-eagle. It is a great way to put both a Top and bottom who may be new to bondage at ease and have a very enjoyable session before exploring more complicated ties.

With a male bottom, this position is great for foreplay but it does not lend itself to anal sex. Please see the variations or just flip your bottom over and go for it! Of course, you could just be extra nice and ride him while he is bound.

1. Position the bottom laying face up in the middle of the bed and begin with either wrist.

2. Fold the rope in half (use short to medium length) and place loop just under the palm of the bottom's hand. Bring the rope around the wrist once and back through the loop to create reverse tension. Be sure that you can fit a finger between the wrist and the rope so that it isn't too tight.

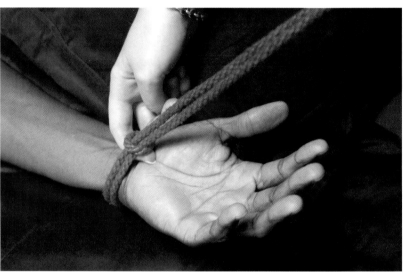

3. Wrap the rope back around the wrist two more times and pass the remaining length through the starting (reverse tension) loop.

4. Take the remainder of the rope under the wrist tie and make another loop that all of the rope will pass through. This is called a lark's head and effectively locks the tie off so that it will not get tighter when tension is applied.

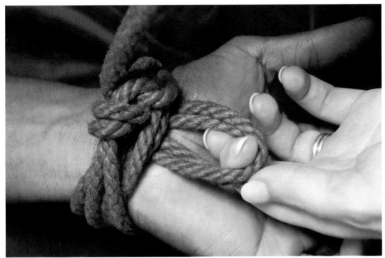

A

B

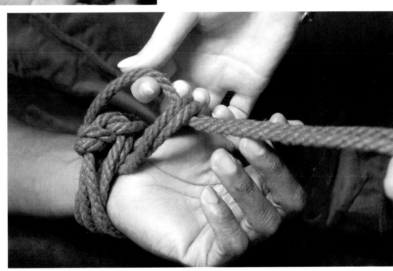

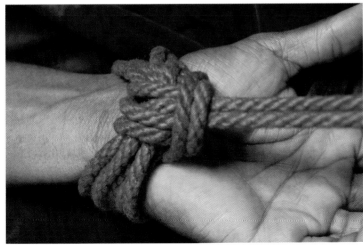

C

5. You should have enough rope left to tie off to the leg of the bed. If not, add more. When tying to an external structure, there are many options to consider. This position does not need to bear weight (but there will be tension), so you could do something as simple as wrapping the remaining rope around the bed leg once and finishing with a square knot.

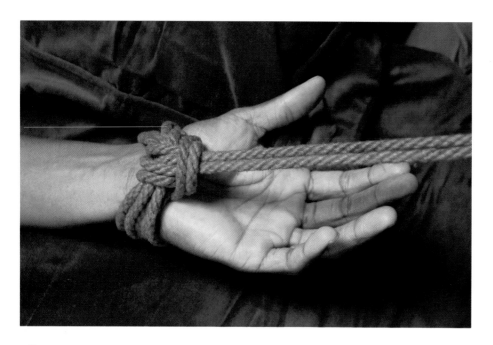

6. Repeat the above steps for the other wrist and both ankles. Tie all limbs off to the appropriate corners of the bed and you're ready to start having bondage sex.

A

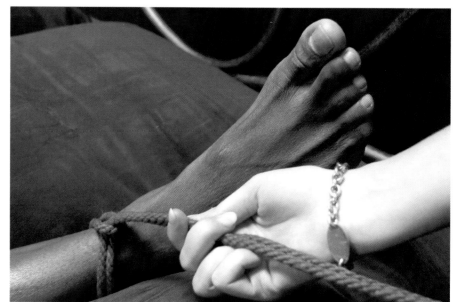

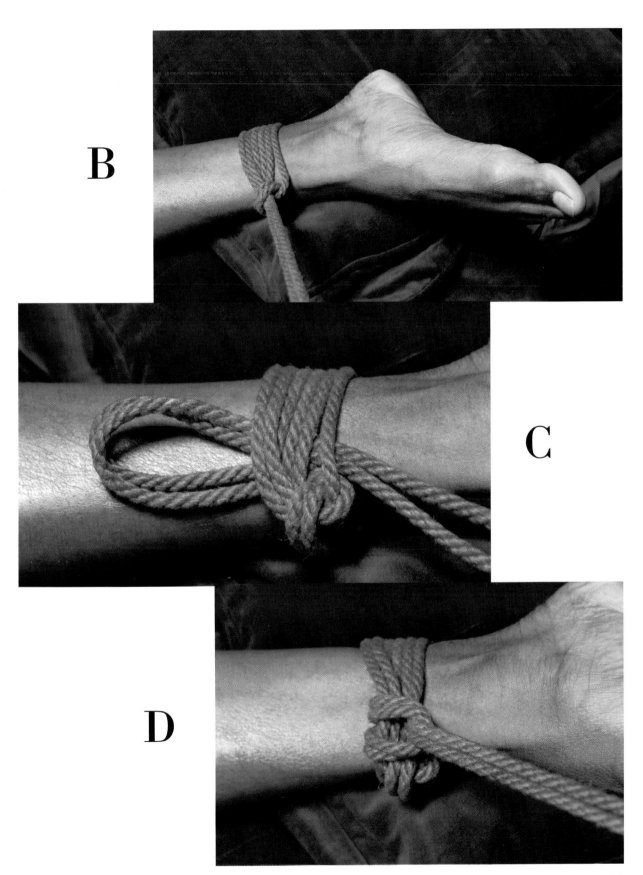

B

C

D

29

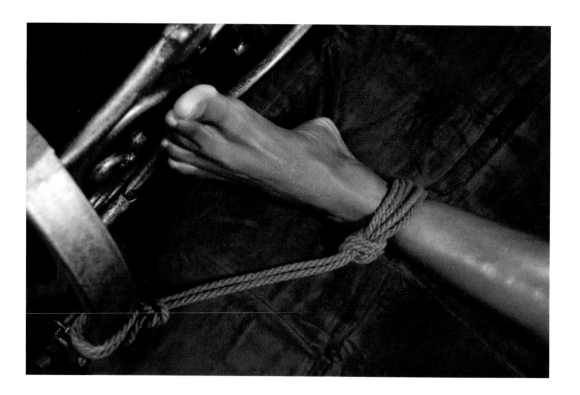

Points to Consider:

This position places some tension, or "pull," on the hands. Most bondage is applied not to wrists and ankles but to forearms and calves, which is less likely to cause numbness. The Top should monitor the temperature of the bottom's hands and any color change that may occur. Make sure you can slide a finger underneath all ropes and that knots are not pressing on ankle or wrist bones. The knot for the wrist tie should rest just under the base of the palm and the rope should act as something the bottom can grab on to for leverage whilst in the throes of passion.

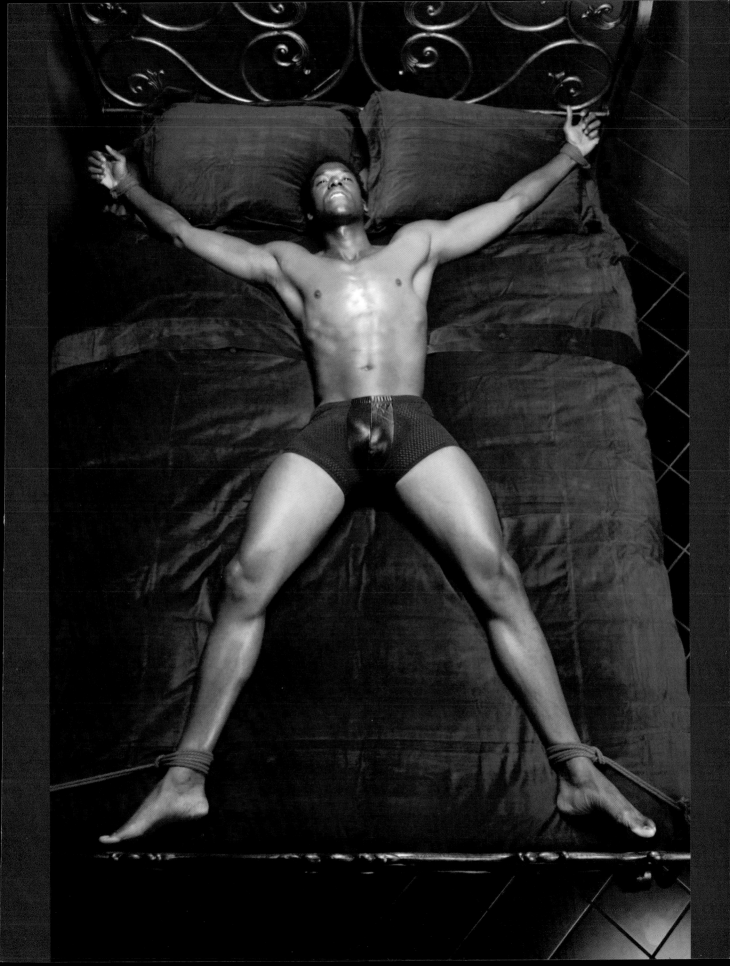

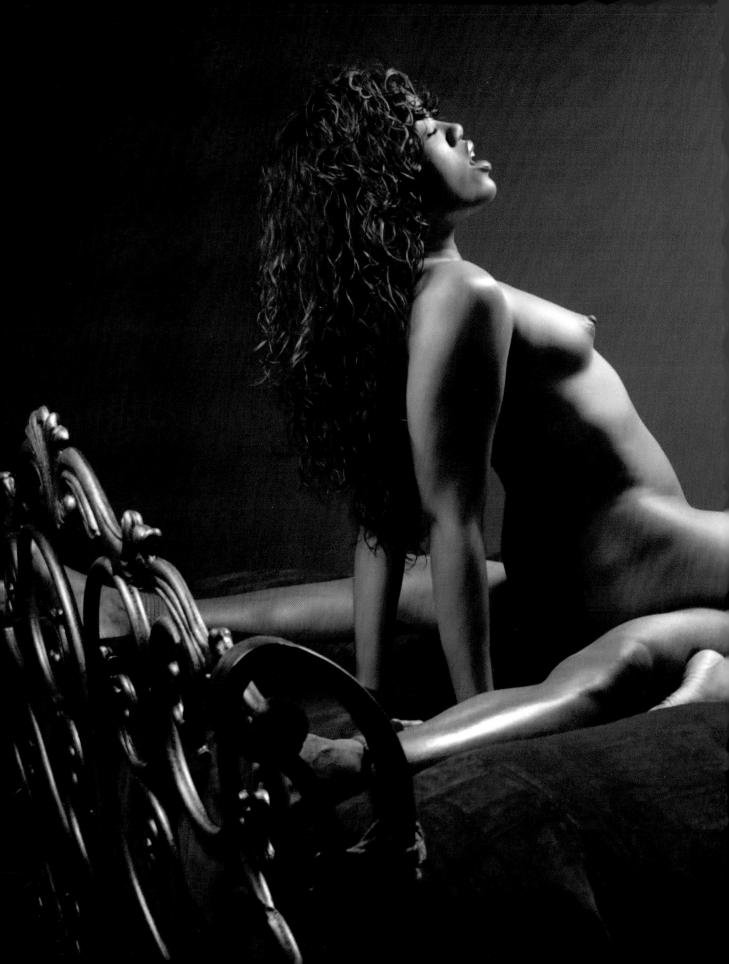

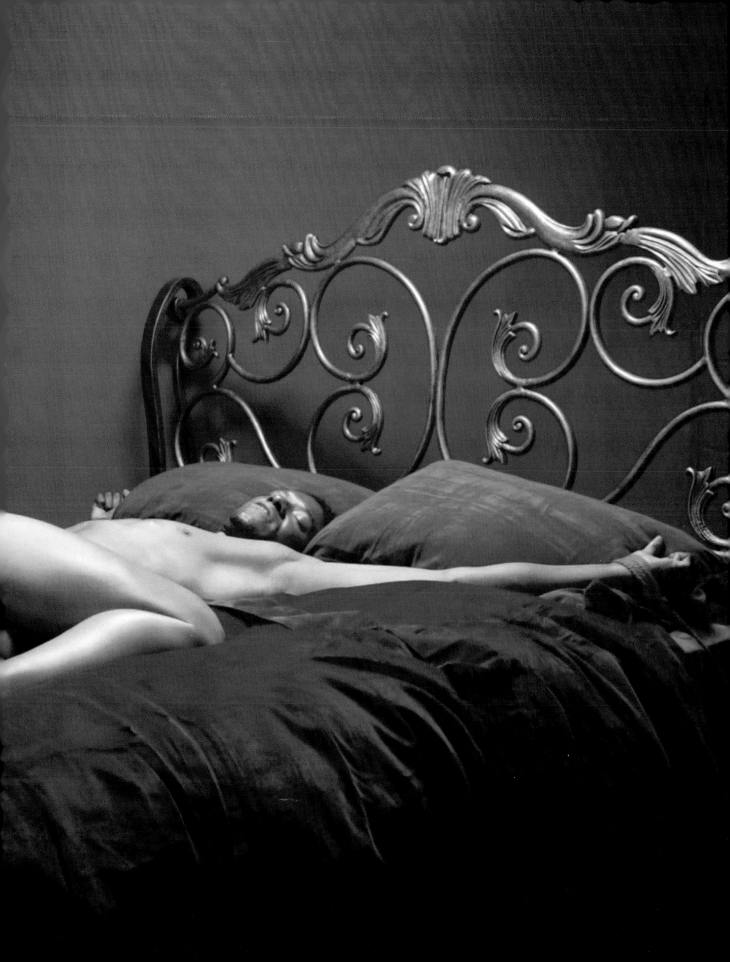

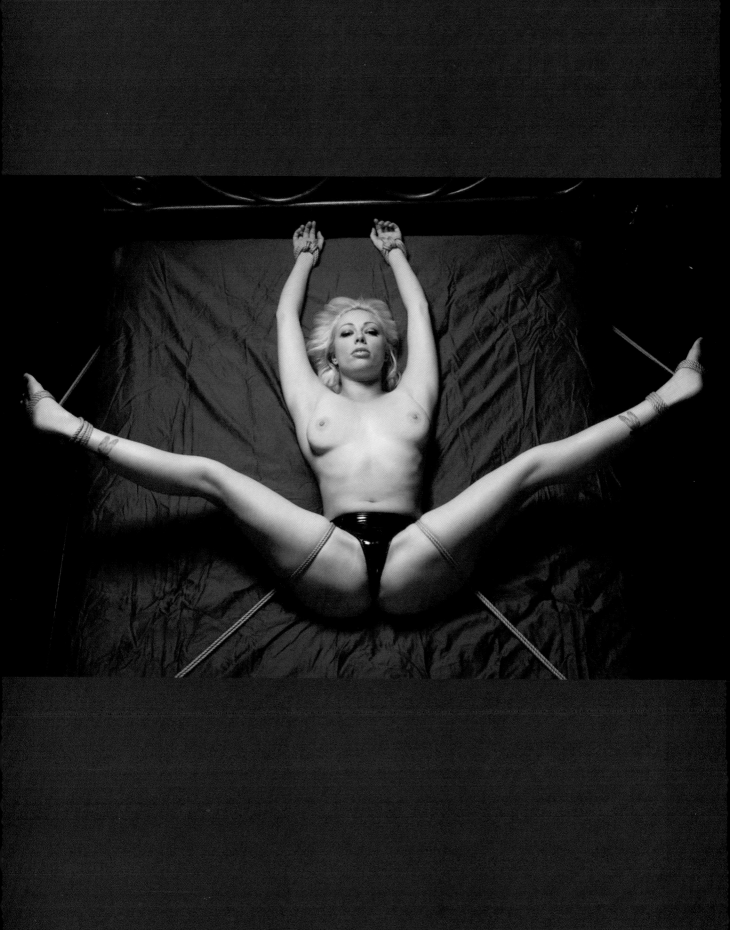

Variation: Pull Legs Back

When it comes time for the sex, the spread-eagle (on a female bottom) offers only shallow penetration. It is a nice tease, and the feeling of a pelvis grinding against the clitoris is delightful, but if you want to move into some deep, hard fucking, the position will have to change slightly. With the legs pulled back, the bottom's sex is prominently displayed and easily accessible for deeper penetration.

1. To make the ankle tie a little more comfortable when pressure is applied, make a quick change to a basic foot harness. Untie the ankle rope from the bed leg but leave the ankle bondage in place.

2. Wrap the remaining rope around under the middle of the sole and create reverse tension.

3. Return back under the sole again and bring the rope through the loop that was created when reverse tension was applied.

4. Bring the rope underneath all layers, make a loop and finish with a lark's head.

5. Pull the leg back and secure the remaining rope to either the bed legs where the wrists are tied or to wooden slats under the mattress (more of a side pull than a back pull).

6. Do the same with the other leg.

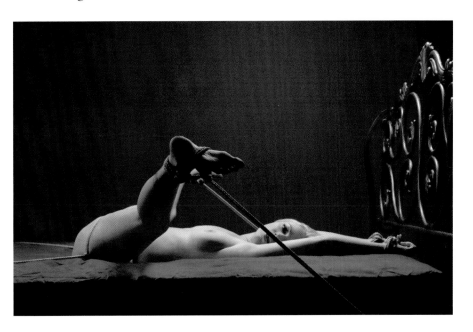

7. At this point the bottom is being pulled in only one direction, meaning that if she wriggles up the bed all of the tension will be gone. To fix this, simply apply rope to each thigh with a quick lark's head and tie off to the opposite corners of the bed. Now your bottom can't struggle away.

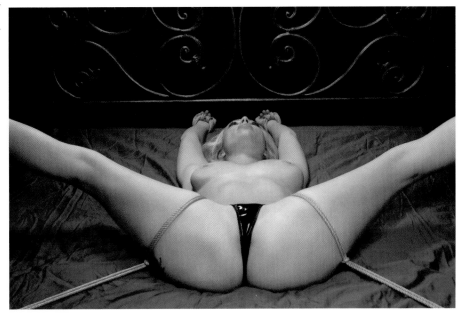

8. If you would also like to change the hand position, simply untie from the bed legs and pull the arms back over the head of the bottom. Tie the remaining lengths of rope straight back. This will give an "arms over head" look without the intensity of tying the hands together.

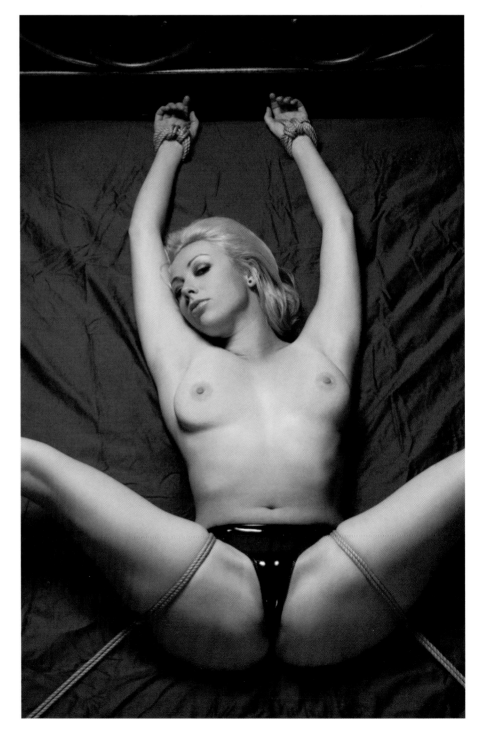

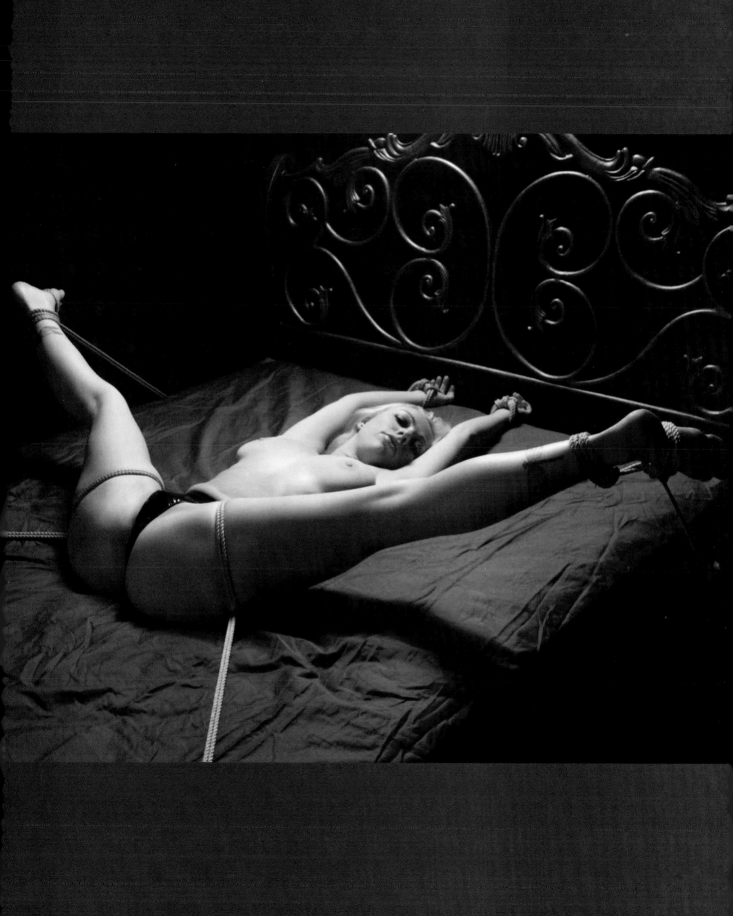

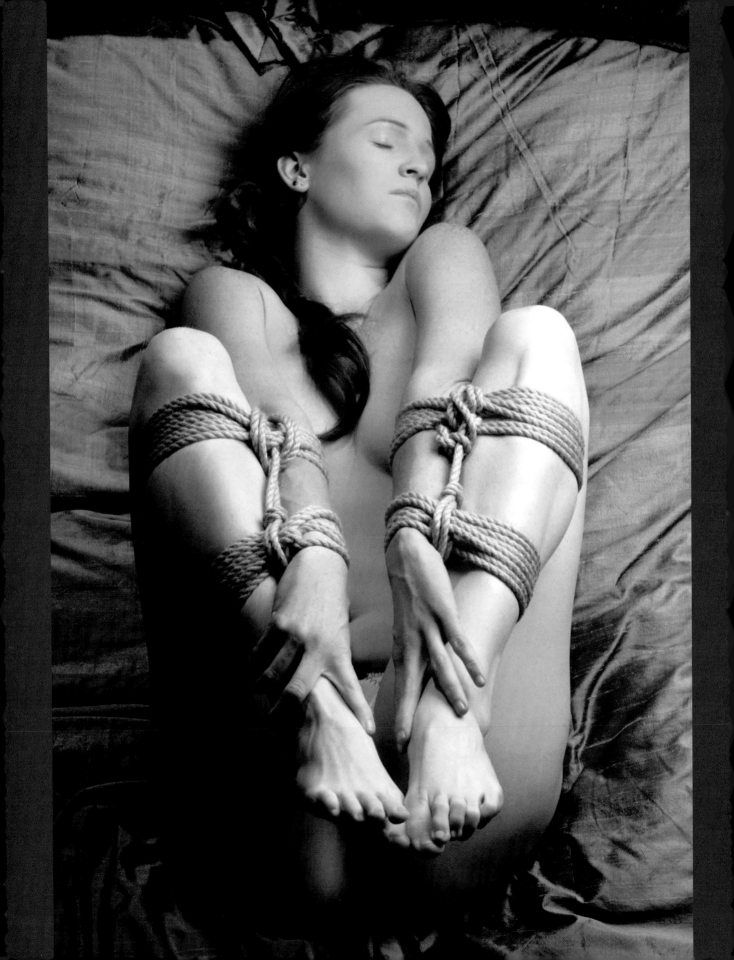

Crab Tie

The easiest way to begin a crab tie is to have the bottom sit on the bed/floor and lean forward, placing his wrists parallel with his ankles. This can be done with the arms either on the inside or outside of the legs. From my experience I have found arms on the inside more comfortable, but if you plan on adding a spreader bar to keep the bottom's legs spread I would recommend rigging this position with the arms on the outside of the legs.

1. Take two medium lengths of rope (one for each arm/leg tie) and find the middle. Place the rope around the forearm/shin with the loop on the outside.

2. Go around two more times and create reverse tension by taking all of the rope back through the starting loop.

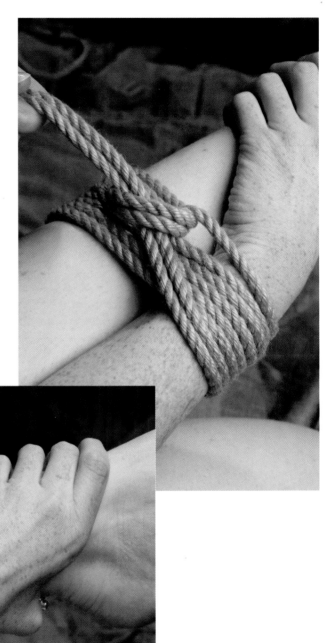

3. Begin to cinch between the shin and forearm, but do not bring the rope all the way through. Instead, make another loop on the outside of the leg towards the knee and make a lark's head.

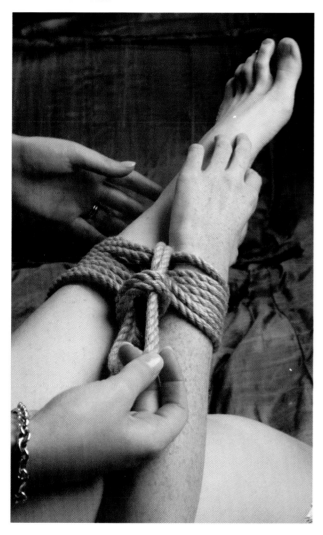

4. Now, take the remaining rope to the upper forearm/upper calf area and loop it around just below the knee and create reverse tension.

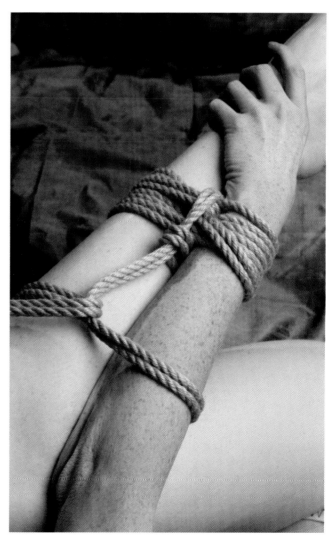

5. From here you can loop back around as many times as you wish, or as the rope length will permit, before locking the tie off with a lark's head.

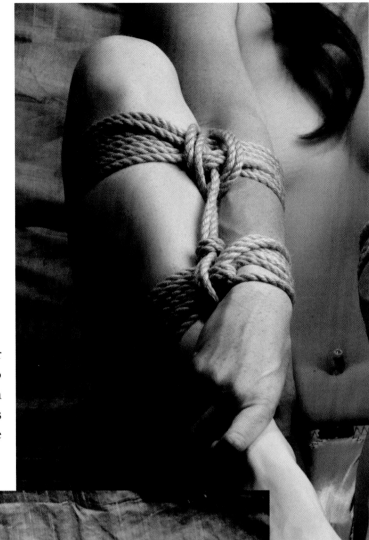

6. Lastly, cinch between the upper calf and lower forearm and be sure to place your knot where your bottom will not be able to reach it with his opposite hand or mouth. Now, do the same with the other arm/leg.

Points to Consider:

When tied carelessly this is one of the easiest positions to escape from. If the element of inescapability is important to you as a Top, then take extra care where you choose to tie knots. Taking this extra care is well worth it, as the crab tie is probably one of the most versatile bondage sex positions available at a basic level. Giving or receiving oral sex is very comfortable, as is vaginal or anal sex, missionary, doggy or spoon.

If you do have suspension points available or a canopy bed, you can easily tie the limbs up so the bottom cannot relax the position easily. This will also display the bottom's sex more prominently than before. As with any tie where the limbs are raised above the head/rest of the body, be sure to keep a lookout for numbness in the feet and hands.

Don't forget my spreader bar suggestion either, and if you're adventurous don't stop there. On a female sub you could tie nipple clamps to the spreader bar (not to the toes, as the bottom will be able to untie them), and on a male sub you could tie the balls to the spreader bar, which would lift them up and display the ass perfectly for a deep anal fucking (this will also work in doggy). With every thrust, the bottom will feel the pull on his tightly bound balls…lovely!

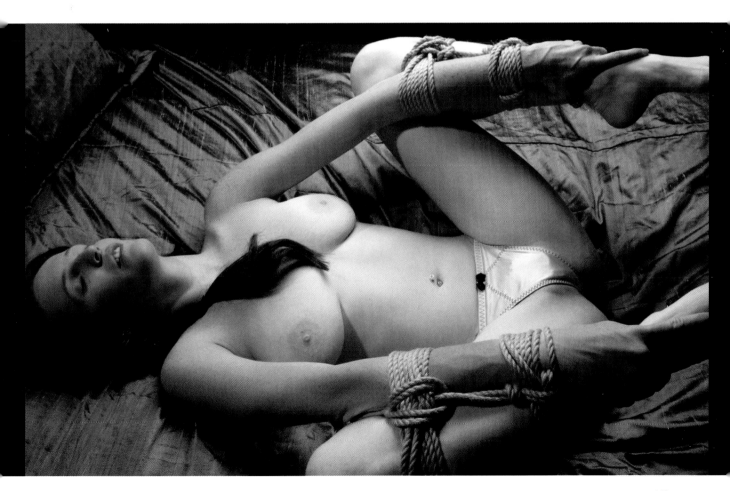

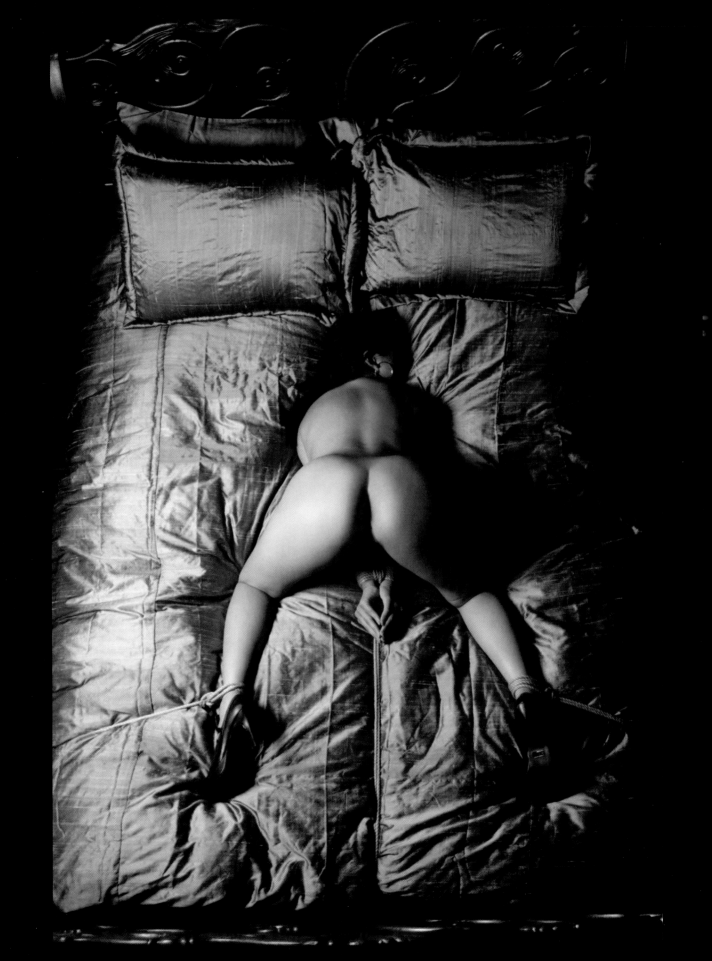

Variation: Doggy Style

This is not a crab tie but it is a nice, comfort-
able alternative. As you will be using the bed
for tie points, you won't be able to move the
bottom around much, but the tie is so com-
fortable that she will still be able to "fuck
back" if you want her to.

1. Start by having the bottom put her
wrists together in front. Take a medium length
rope and loop around the two wrists two to
four times before looping through.

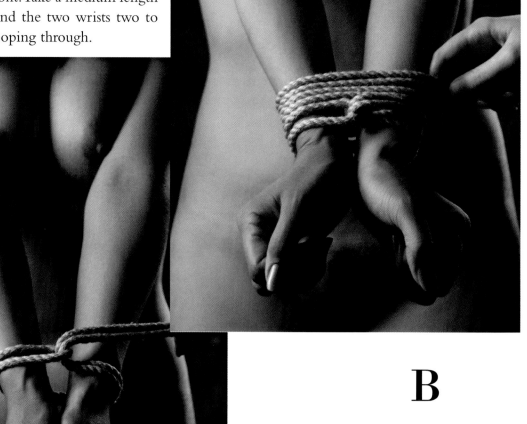

B

A

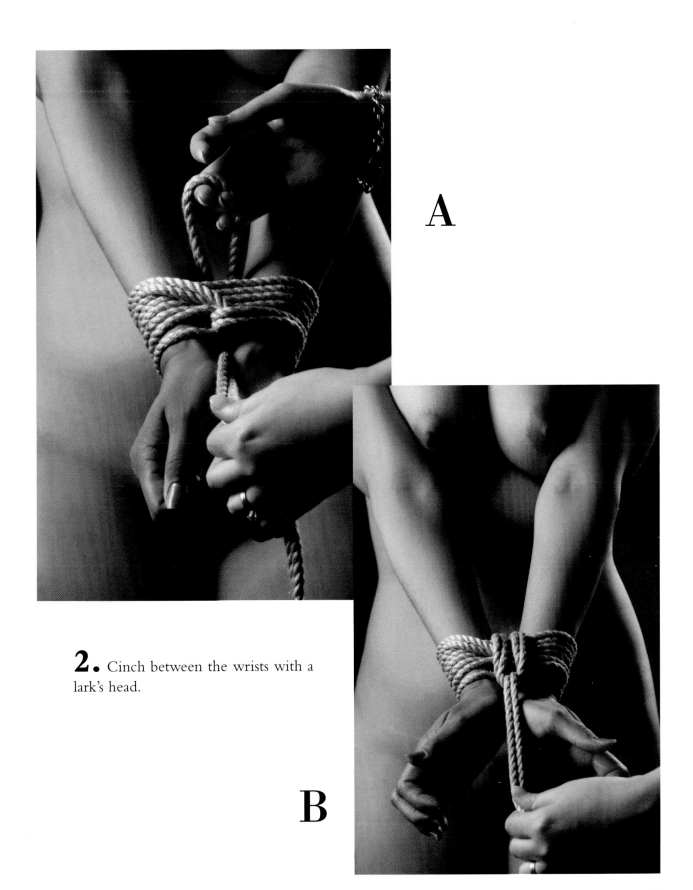

A

2. Cinch between the wrists with a
lark's head.

B

49

3. You will have rope left over. Have the bottom get into doggy position on the bed with her hands underneath. Take the remaining rope and tie off to the bed.

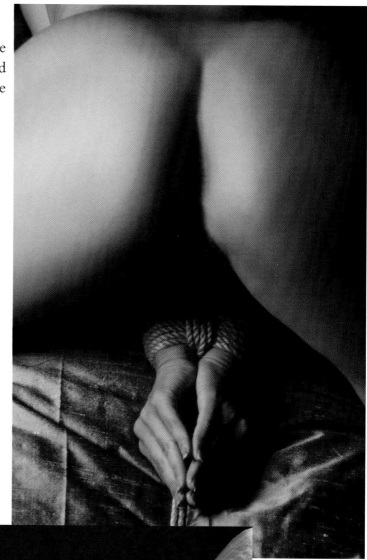

4. With two shorter lengths of rope, tie the ankles as per the spread-eagle position.

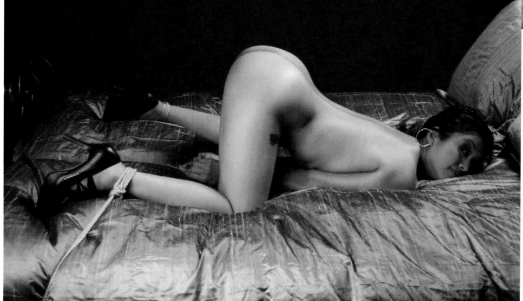

5. After tying each ankle off to the side of the bed, you're ready to have penetrative sex.

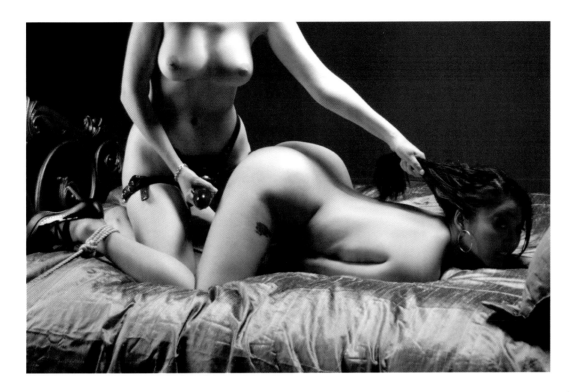

A

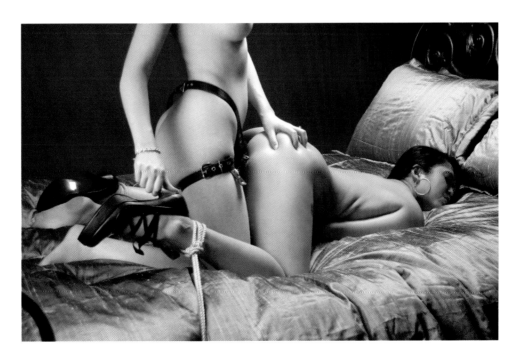

B

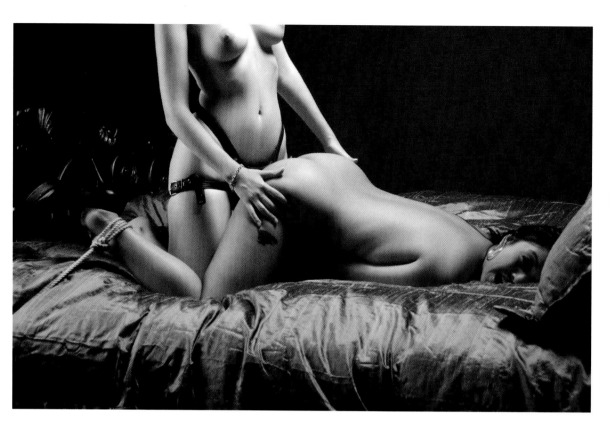

C

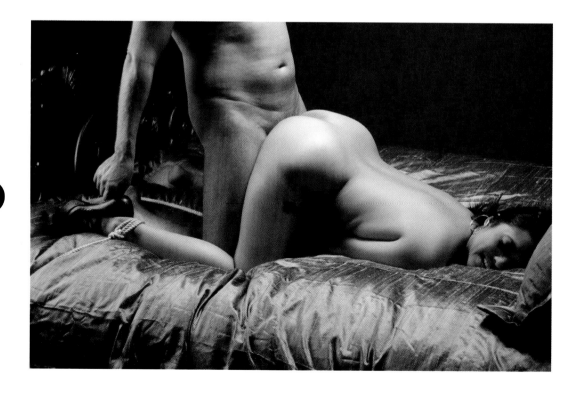

D

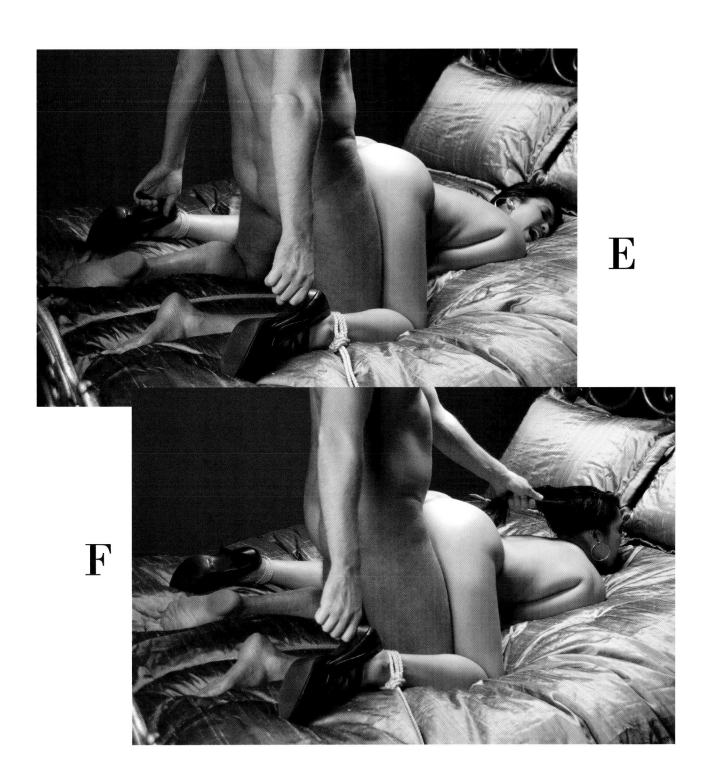

E

F

Points to Consider:

If you feel that the bottom still has too much freedom of movement, you can make the position stricter. Just tie a rope between the two ankles to stop the bottom from being able to spread her legs any further. You can also add a rope to the neck (make sure to lock the tie off) and tie it in the opposite direction of the hands. This will disable the bottom from being able to get up on her knees. Be sure that any pressure is on the back of the neck and not on the throat.

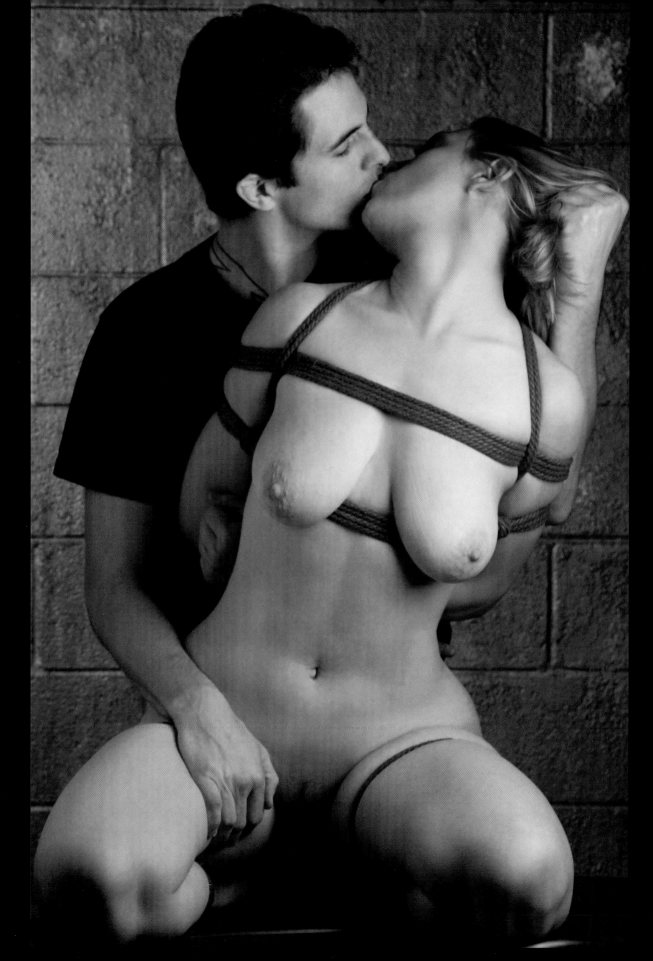

Harness
and
Frogtie

1. Take a long length of rope (I use 50 feet for this) and fold in half. Ask (or command!) your bottom to place her arms in a "box" position behind her back and keep them there. Place the loop on the spine at around breast height and take the rope around under the breast line and bring it through.

This is probably my all-time favorite position for sex. There is something so sexy about the feel of rope around your arms and chest, and the harness gives the Top all sorts of lovely rope "handles" to grab on to while in the throes of passion. Even better is the fact that this position is so versatile. There is no use of external structures, meaning you can do it anywhere without feeling limited if you have nothing to tie to. This also means that your bottom can be moved around roughly like a rag doll and used any way the Top wishes.

With the bottom freshly tied on her knees, oral sex is a real must and the perfect way to start some kinky bondage sex. After that, both pussy and ass are equally accessible. Place the bottom in doggy position for some long, sustained fucking while using the harness for leverage. You can even flip the bottom over for some missionary style sex. If the arms have been comfortably tied in the small of the bottom's back, this, too, will be a very sustainable position. If you have chosen to do a very strict arm tie where the hands are raised and close to the middle of the back, your bottom will now be placing a lot of weight on them and numbness may become a problem.

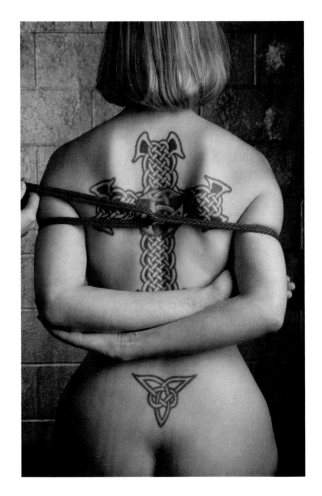

2. Make sure the rope is snug but not too tight. Take the rope back in the opposite direction and again loop it through to create reverse tension.

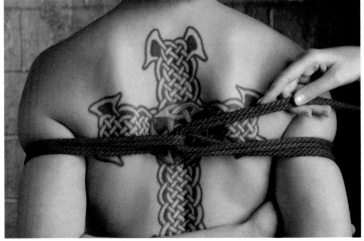

3. On the third time around the rope should be above the nipples on the upper chest area. Loop through again and go back around one more time.

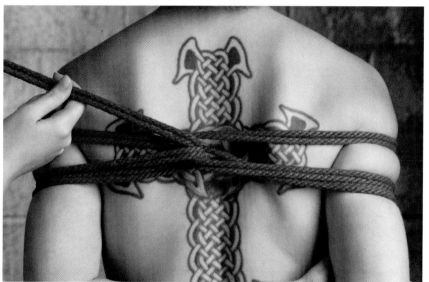

4. You should now have two layers of rope below and above the breasts. Loop the remaining rope through the starting point and make a lark's head to stop the harness from getting tighter.

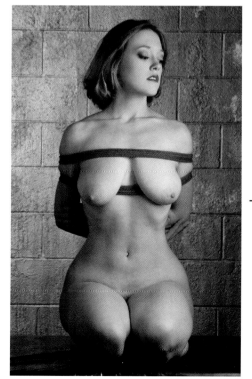

A

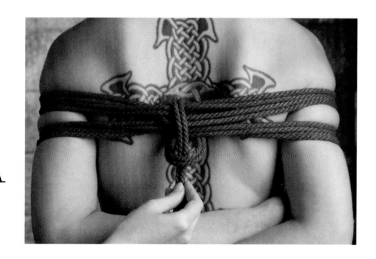

B

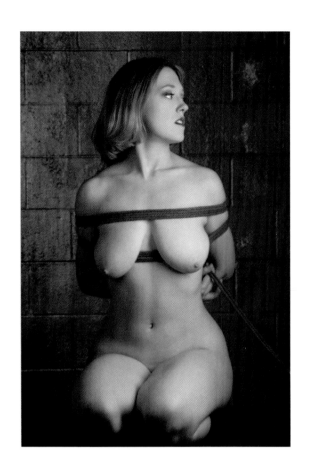

A

5. Take the doubled rope under all of the harness on the left arm, bring it up over the rope that is <u>under</u> the breast line. Repeat on the right arm. You will notice I am "cinching" only the front of the harness and not the back.

C

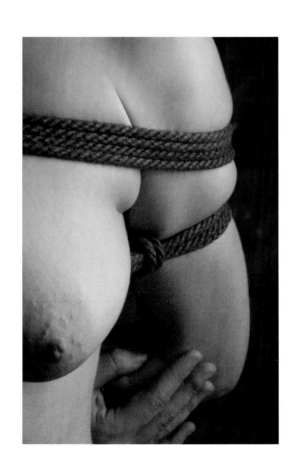

B

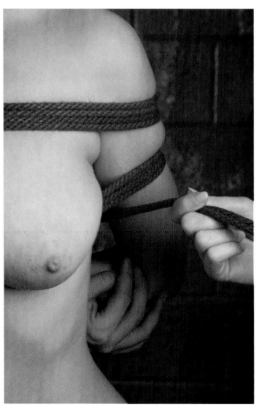

6. Loop back through the base of the harness and take the doubled rope under the right upper harness ropes.

7. Bring the rope around the front of the shoulder, over the back of the neck and around the left shoulder. Bring the rope under the upper ropes of the harness and loop back through at the spine. Tie a lark's head around all of the rope.

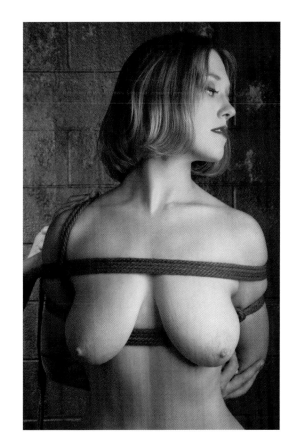

A

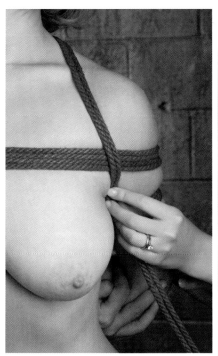

B

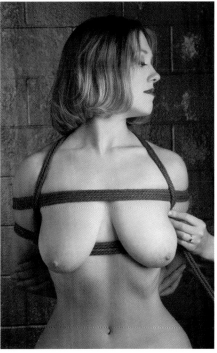

C

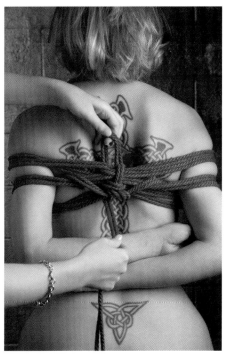

8. Take the remaining rope up behind the neck. Go around the base of the harness and neck rope as many times as necessary (usually two to three) and finish by wrapping over all of this rope many times to create a very attractive and sturdy point to grab on to during sex. Finish with a square knot.

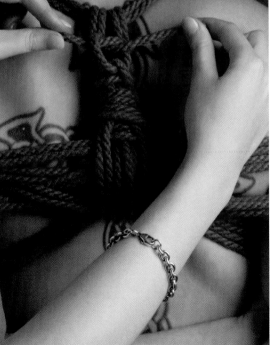

B

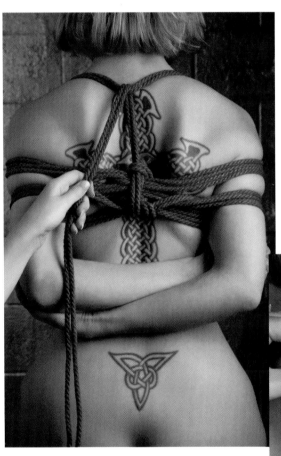

A

C

9. The bottom should still have her arms in the "box" position. Take a short rope, fold in half and wrap the rope around the forearms three to four times. Find the starting loop (should be pointing up) and pass the rope through it. Take the rope underneath and make a lark's head on top.

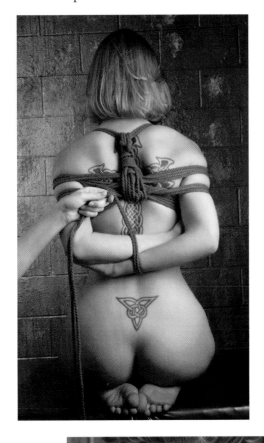

A

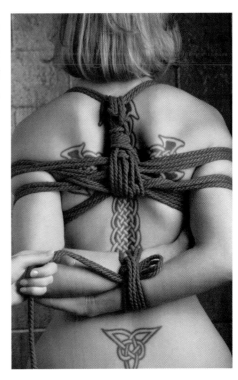

C

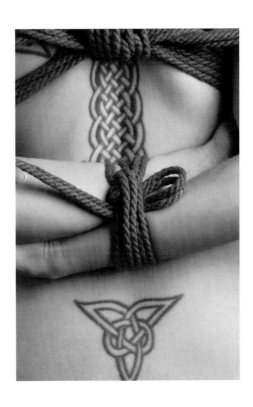

D

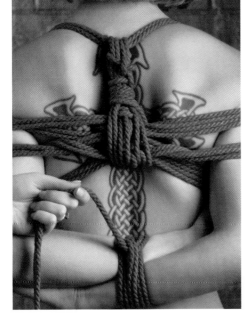

B

10. The remainder of the rope can then be used to attach the arm tie to the chest harness. Remember, it will be most comfortable if you do not pull the hands up high on the back.

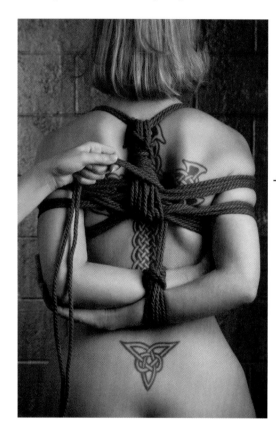

A

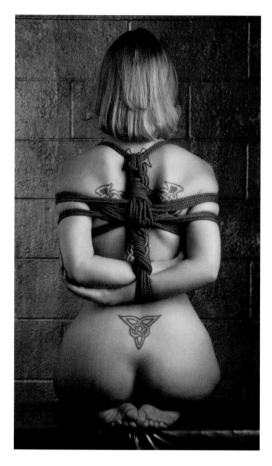

C

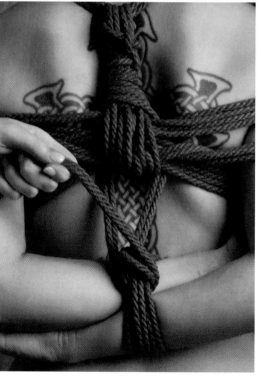

B

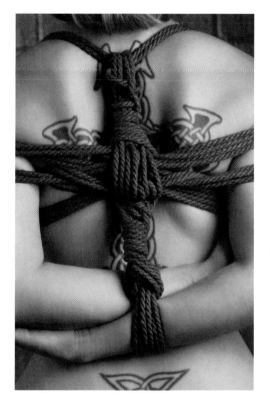

D

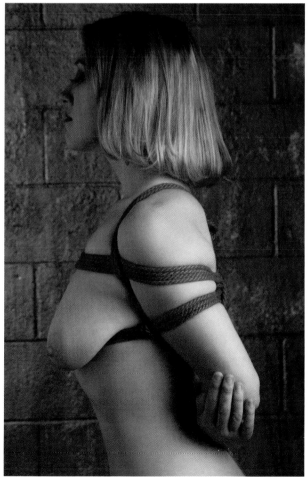

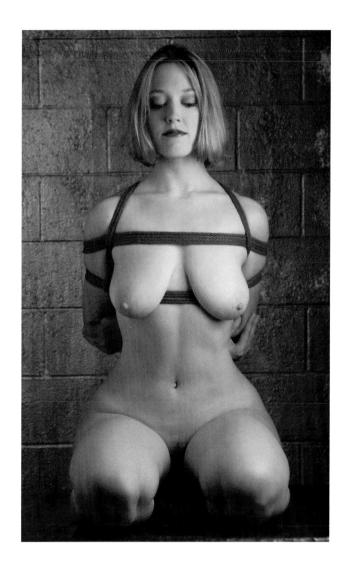

E

F

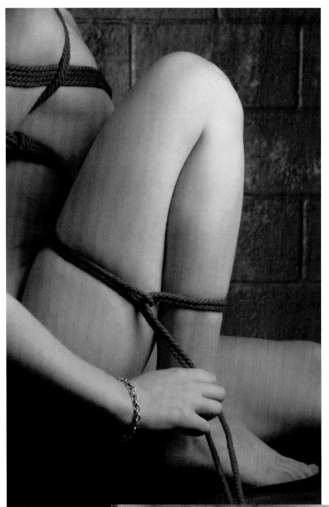

11. Place the legs in the frog position and fold your rope in half. Place the loop between the thigh and calf on the outside of the tie. Wrap around two to three times and loop through the starting point.

A

B

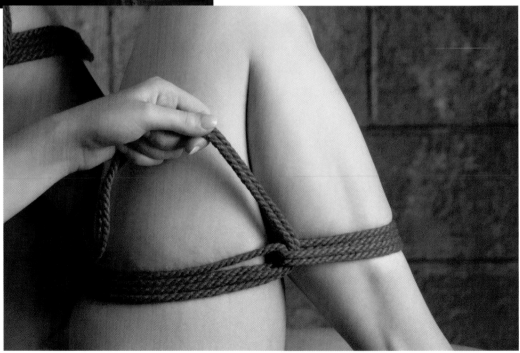

12. Take the rope between the calf and thigh and cinch one to two times. Finish with hitch, square or knot of your choice.

A

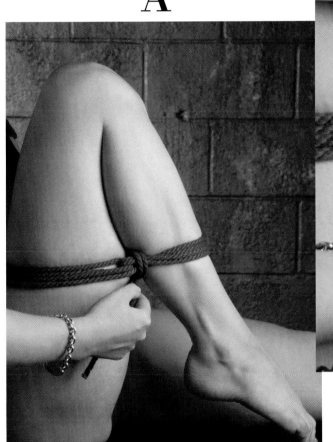

B

Points to Consider:

Notice that I did not cinch the arm (wrist) tie? This is because the rope over the upper arms should make it impossible for someone to struggle out of this bondage. If your harness is loose, you may find that the arm tie is ineffective and the bondage is escapable. Remember to maintain tension throughout applying the harness to avoid this. The position will also be more difficult to tie if you have a "fidgety" bottom, so order her to stay still and, if you don't want to have to walk in circles to apply the harness, make the bottom turn around on command while you tie. The frogtie is great for sex, but if done too strictly you could find the bottom's feet are in the way. Either loosen the tie (so that the backs of the thigh and calf are not touching so closely) or tie the legs a different way (there are more suggestion in upcoming chapters).

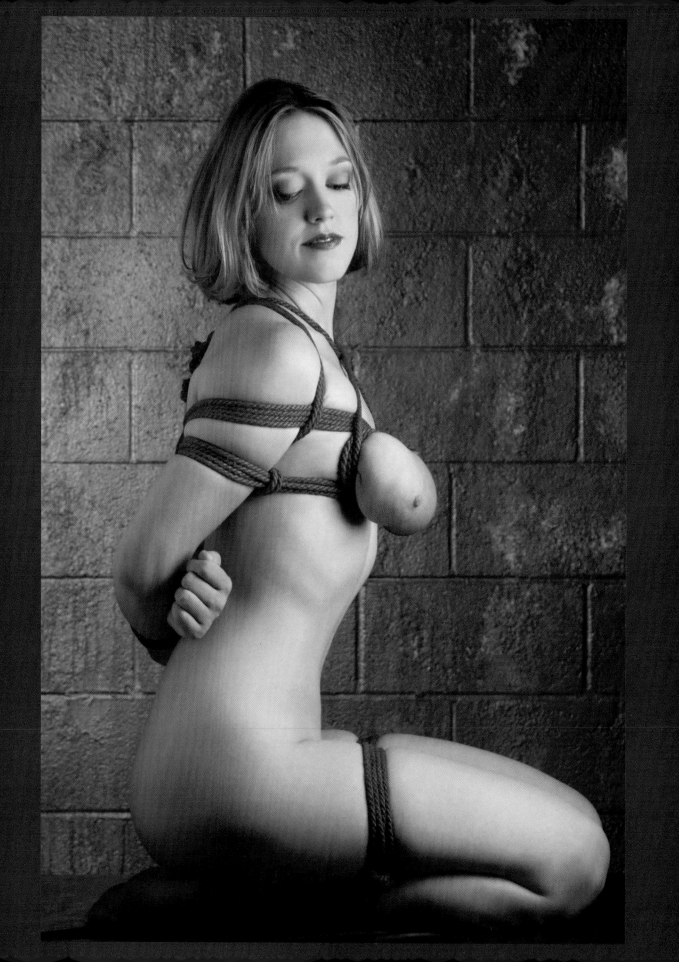

Variation: Add Breast Bondage

Mmm. There is something so lovely about seeing bound breasts. Feel free to play around with your tying material for this. Just because you may have used 1/4-inch hemp for the harness does not mean you are limited to this for the breast bondage. Try twine or thin pieces of leather instead. You will also find it easier to bind smaller breasts with thinner materials than rope.

1. Take one of your shorter lengths of rope (12.5/15 feet) and fold in half. Place the looped rope under the desired layers of the existing breast harness (I usually do all but this is merely a personal preference) and make a lark's head.

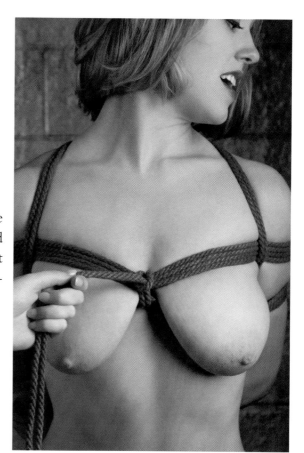

B

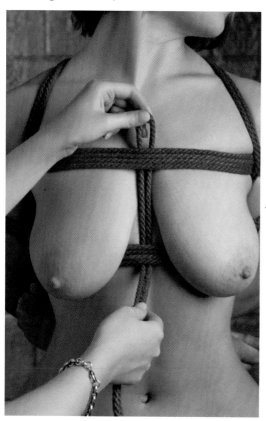

A

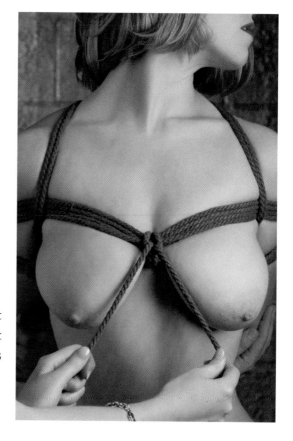

2. Slowly tighten the knot until you feel it can't be tightened anymore. The breasts will already start to bulge with this action. Now treat the two lengths of rope as separate and use one for each breast.

68

3. Wrap the rope under and around each breast and maintain tension. Depending on the breasts, it may be easier to apply if you have the bottom lean forward so that the breasts "hang" more.

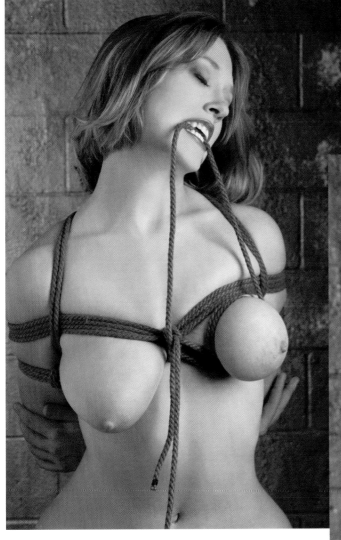

A

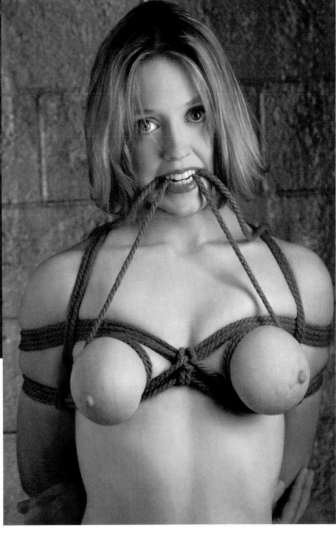

B

4. Wrap two to four times before crossing the ropes over one another (make an X under the neck). This X should not place any pressure on the throat.

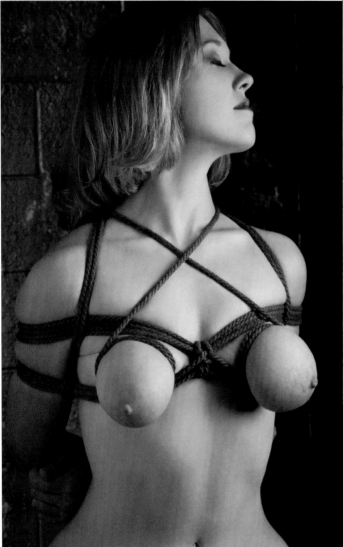

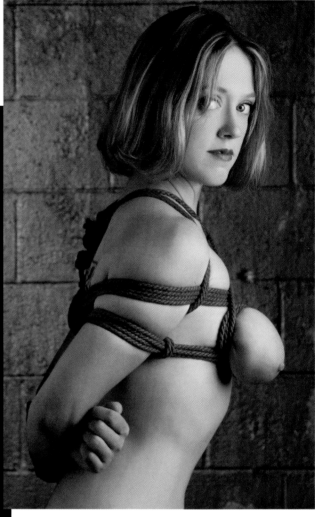

5. Tie the remaining rope off onto the base of the chest harness.

Points to Consider:

Just like testicles, breasts are very individual. Smaller, very perky breasts are not eligible for this tie and you'll generally find larger breasts the easiest to tie in this manner. Personally, I do not find breast bondage to be painful. Even when my breasts are purple and engorged it feels fine to me, but some people can find it visually disturbing and discoloration can happen very quickly. Always communicate with the bottom as to how she feels with this and, as with any part of the body, always check for numbness.

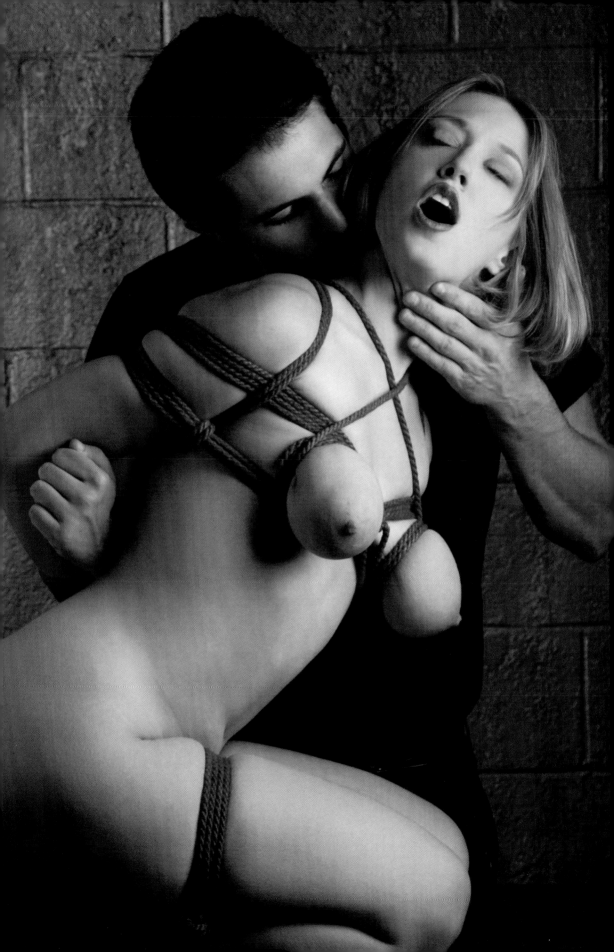

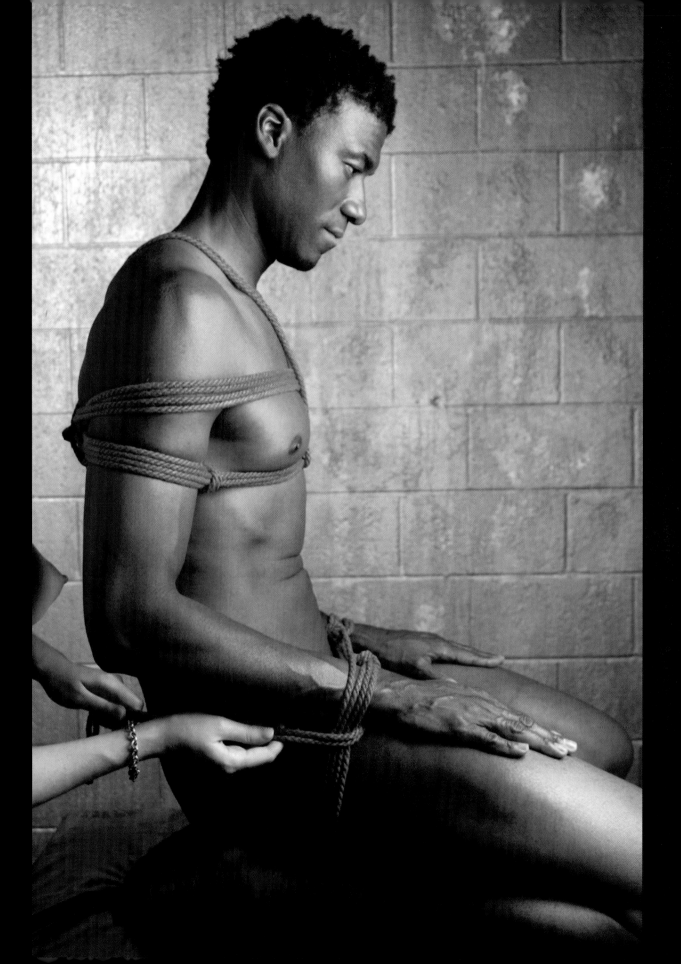

Variation:

Arms by

Side

Should your preference be for missionary style sex, it may be best to have the bottom in a position where weight is not placed on the arms. This slight change in the harness and arm position will protect the bottom from injury and provide a front "handle" for the Top to use for leverage when fucking. This is also the perfect alternative if your bottom is not flexible enough to do the "box" position.

1. Release the hands from the box tie and have the bottom place them by her side.

2. Check the harness to see if it has loosened much now that the arms are positioned differently. If so, you may want to modify the harness slightly to give you a front handle to use during sex. Untie the harness until you are at the point where there is a cinch under each arm and then take the rope over the bottom's shoulders and make a nice tight lark's head between the breasts. Bring the rest of the rope over the opposite shoulder and finish off the harness. Note: This will only work on a bottom who has breasts. You can see in the images of the male bottom I have bound that I have done a "male" variation for this also.

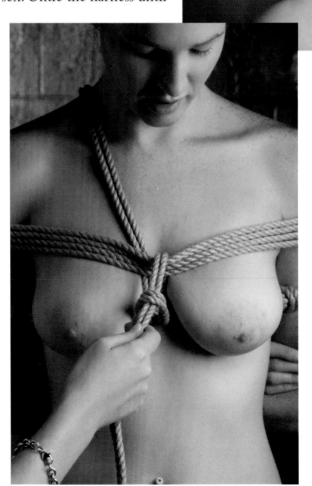

A

B

74

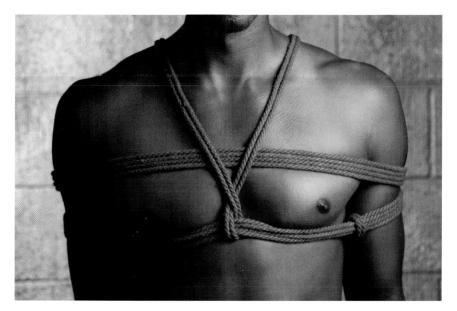

3. Take two of your shorter ropes to use one on each forearm. Fold the rope in half and wrap it around the forearm and the upper thigh to make a loop between the two. You are, in effect, tying the arm to the thigh.

4. Go around the thigh/arm again, looping back through the original loop.

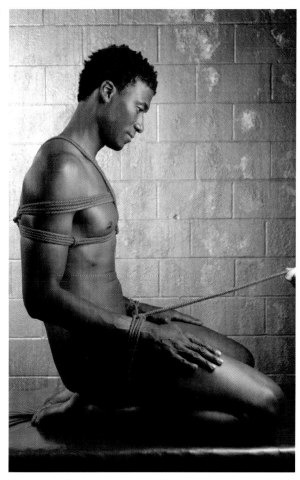

5. Take the rope between the arm and thigh a couple of times to cinch and then finish with a double overhand knot.

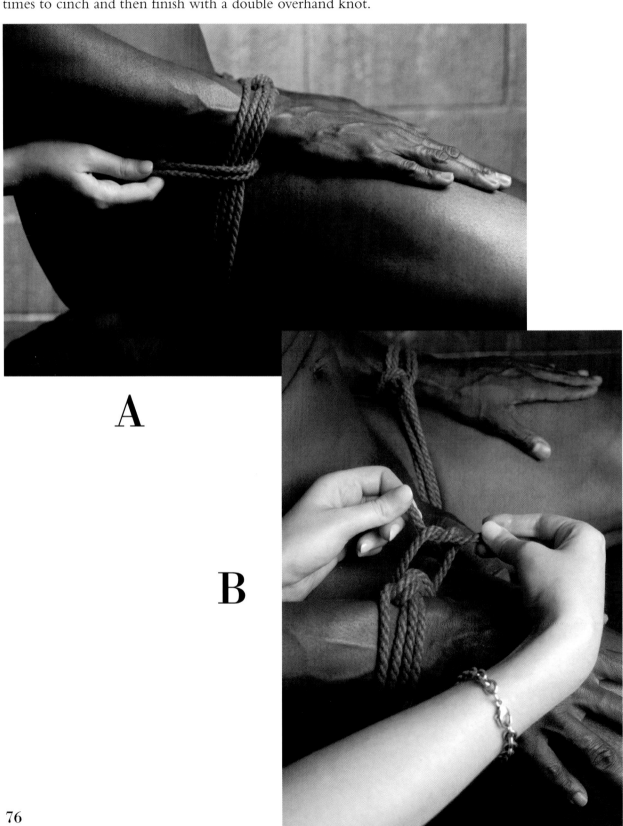

A

B

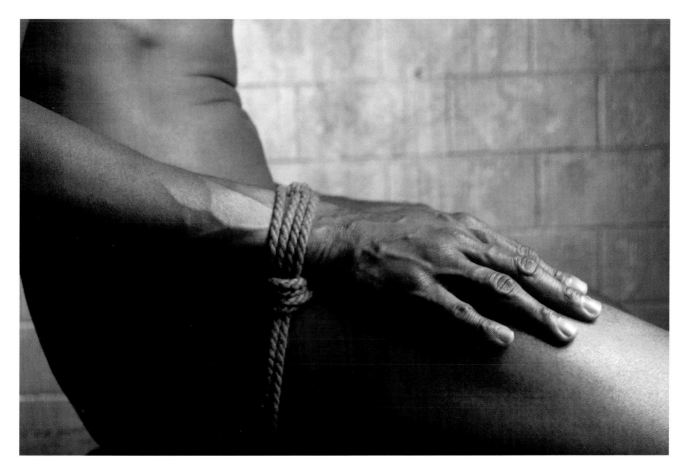

C

Points to Consider:

If you place the finishing knot under the hand, it will be easy for a sneaky bottom to untie. Always be sure to place knots where struggling hands cannot get to them, in this case above the wrist.

Different people have different length arms. This tie works best when you can bind the thigh and the forearm just above the wrist bone.

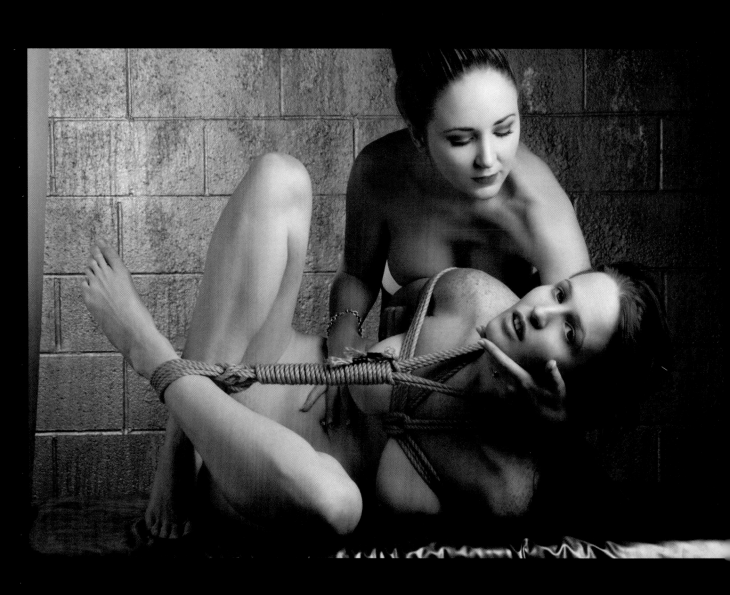

Variation:

Cross Legged

Bondage

This is a very traditional Japanese (shibari) position called the "Agura." It may appear to be rather basic, but it is a lot more challenging than you may think. Any position where pressure is placed on the back of the neck, forcing the bottom's head forward, really starts to take its toll after a few minutes. If you are playing on a bed or comfortable surface, the agura will be more sustainable.

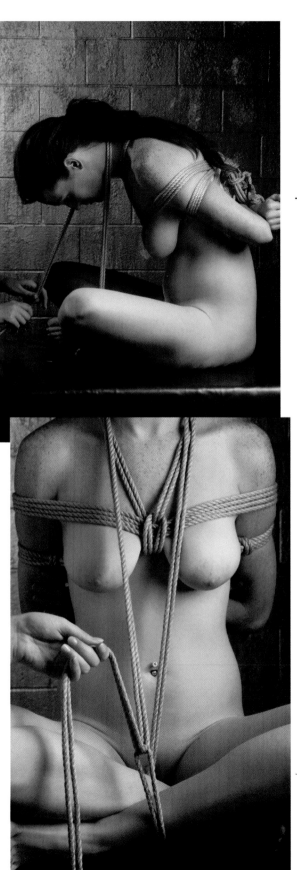

A

Personally, I never found this to be one of the most sexable positions. I can only give a mediocre, shallow blowjob when in it and find that I am almost always struggling against my binds in a way that may look as if I am desperately trying to escape. Of course, it is these very actions that make the position so appealing to the Top.

My play partner and I did discover, though, that when in the agura, I have some of my most powerful orgasms. It is fabulous for back flogging, vibrating and fingering, but the way I really enjoy it is to be placed laying on my side with my pussy and ass fully on display. The Top can choose which hole to penetrate and has easy access to my clit. For a male bottom, there would be adequate access to the balls. When lying sideways, some of the pressure on the back of the neck is relieved and the bottom can melt into the sexual activity the agura lends itself to.

B

1. Take a longer length of rope and find the middle. Take the entire rope around the back of the neck and under the crossed legs of the bottom. Loop through just above the crossed ankles. Make sure the bottom is leaning forward as to make the position strict.

2. Create reverse tension and do the same again. Loop through the starting loop and then make a lark's head around all of the rope at the ankles. As you will not be cinching the ankle tie, be sure to tie this tight and low just above (but not on) the anklebone.

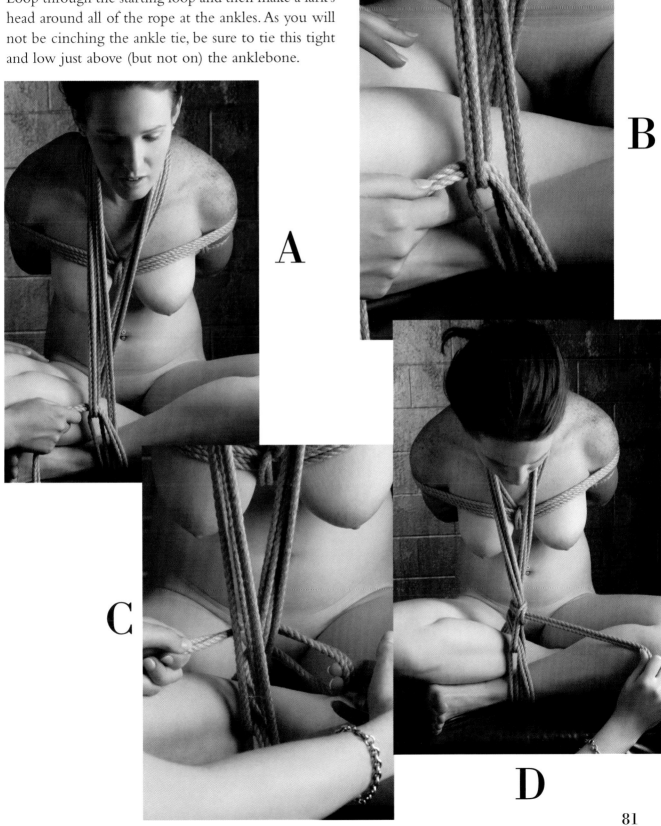

A

B

C

D

3. Take the remaining rope and start looping around all of the rope that is leading to the neck. Just keep wrapping around and around until you have only a few inches left.

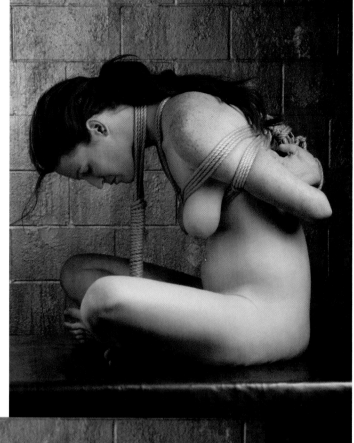

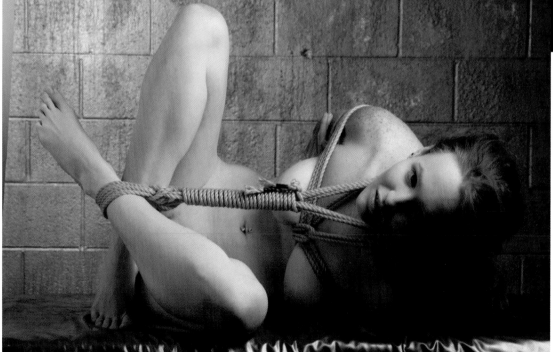

4. Split the rope and finish the tie with a square knot.

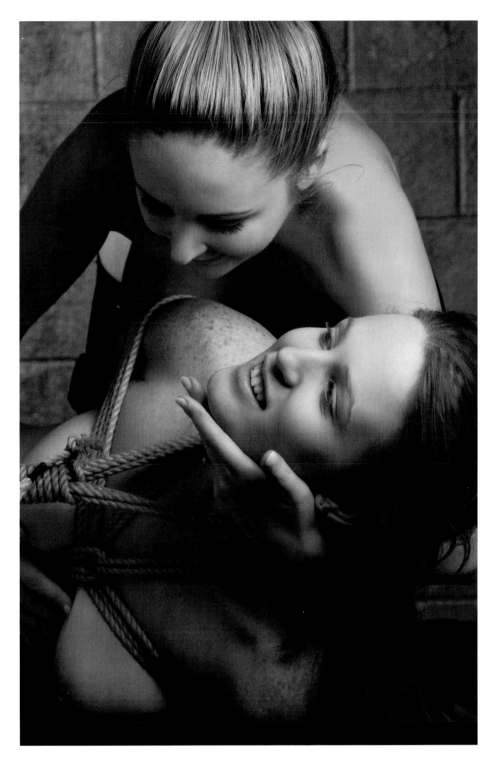

Points to Consider:

This is a very strenuous position on the back of the bottom's neck. For extended play it is best to lay the bottom on his side with a pillow under the head or on his back, where he can relieve the pressure by pulling up his legs. Of course, both of these options involve putting weight on the hands/arms so be aware of this. Don't be scared off. This is not a limiting position for play, but rather one where you have the delightful option of constantly moving your bottom around to relieve different pressure. Use the variety to your advantage and make it part of the scene.

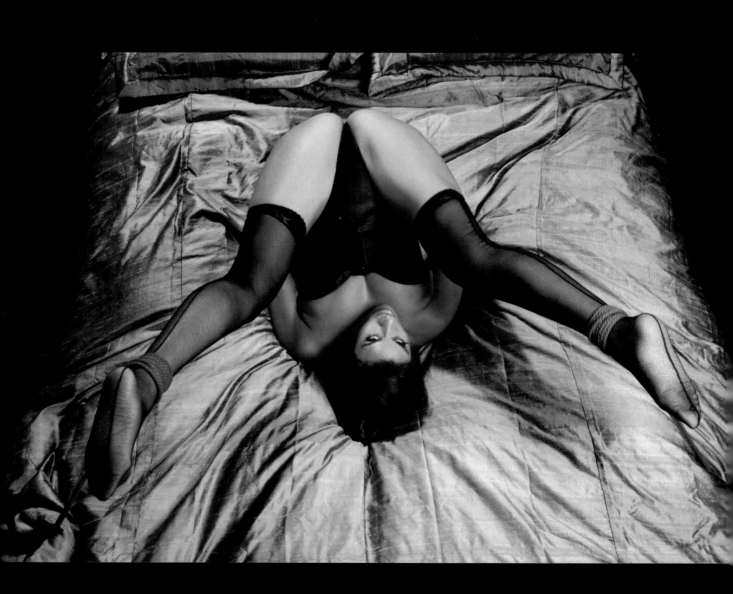

Open

Leg Pile

Driver

I know this looks like a position you would only see a flexible 20-year-old do in a porn movie, but it is not as difficult as it seems, especially when done on a nice, soft bed. The Open Leg Pile Driver presents the ass/pussy/cock and balls so nicely for some punishment, I couldn't resist including it. My play partner has tied me like this while he held the magic wand on my clitoris and it felt amazing. I have also used a strap-on on female bottom's this way to both of our pleasure. I found it most appealing to be above my bottom where I could grab her ass for leverage while I moved my cock in and out. This position can be a little strenuous on the bottom's neck, but being on a soft surface helps this immensely. Best of all, it is as simple to tie as the spread-eagle.

1. Apply bondage to both ankles as with the spread-eagle (use foot harness if you prefer).

2. Have the bottom rest both of her hands palm down on the lower back/upper ass area and fold a medium length rope in half.

3. Place the loop above the coccyx bone just above where the wrists are and bring the rope around the bottom's waist twice, looping it through when done

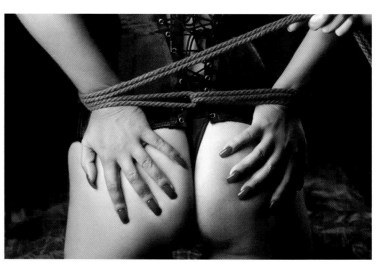

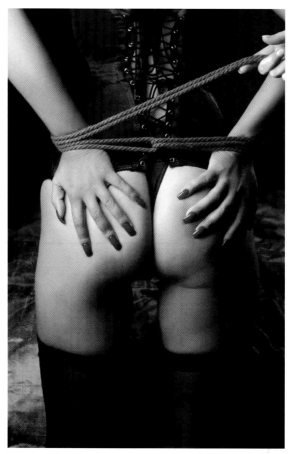

4. Make a "lock off" lark's head so that this part of the bondage cannot get tighter and then treat the two ropes as separate (as with the breast binding). Rope that is too tight on the waist can cause lightheadedness and nausea.

5. Take each rope and cinch the forearm/wrist several times before returning to the beginning loop and finishing with a square knot. This tie will give support to the lower back when in the completed position and also help with the bottom's balance.

A

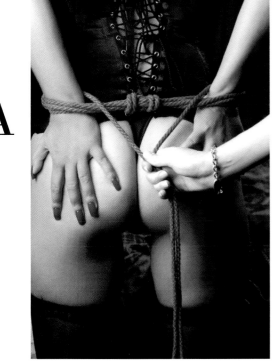

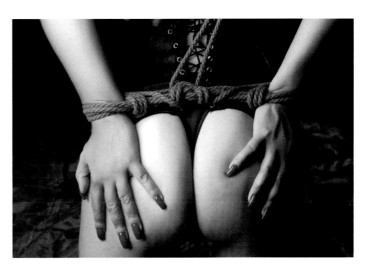

A

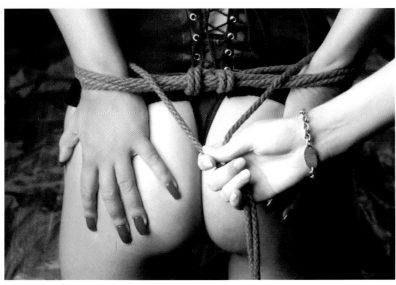

B

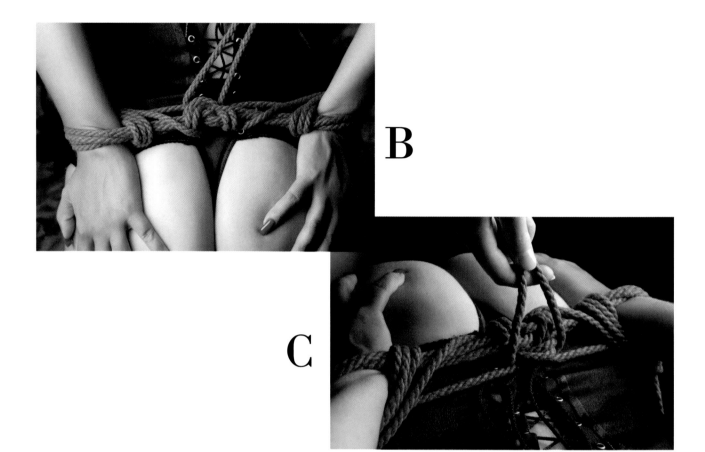

B

C

6. Have the bottom lay in the centre of the bed and assist in "flipping" her up into the pile driver position. Once there, instruct the bottom to place weight on her elbows for support. .

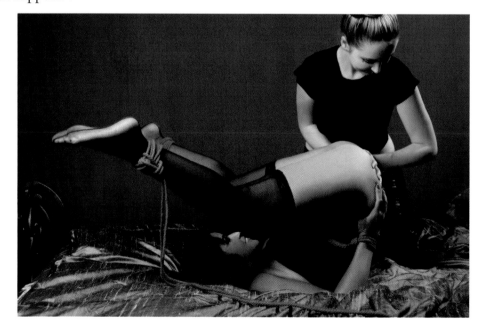

7. Tie each ankle off to a different bed leg and let the fun begin.

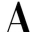

A

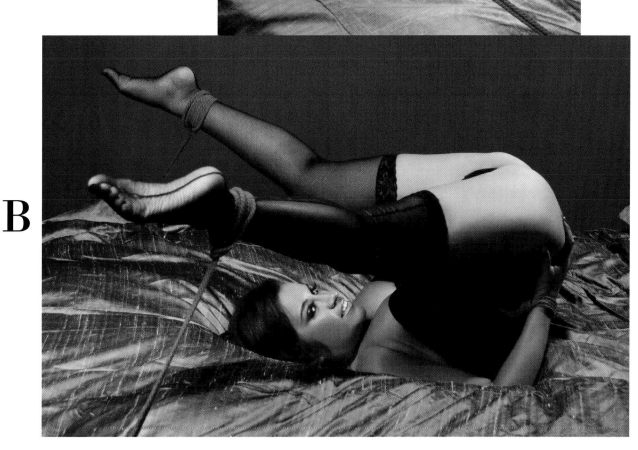

B

Points to Consider:

As the arm tie is helping support the bottom's weight, the hands have quite a lot of pressure on them. The Top should keep a watchful eye out for any warning signs. If you have a flexible bottom, be sure to flip her over fully so that her feet are also on the bed. This will help take some of the weight off the hands and make anal or vaginal sex more easily accessible. In the image, you see that the model has her legs "floating" in the air. This makes the position more difficult. Ideally, your bottom will be able to rest her feet on the surface of the bed, therefore distributing the weight on the arms and the feet, not on the neck. If this is not possible, the position is still fine for sex but will not be as sustainable.

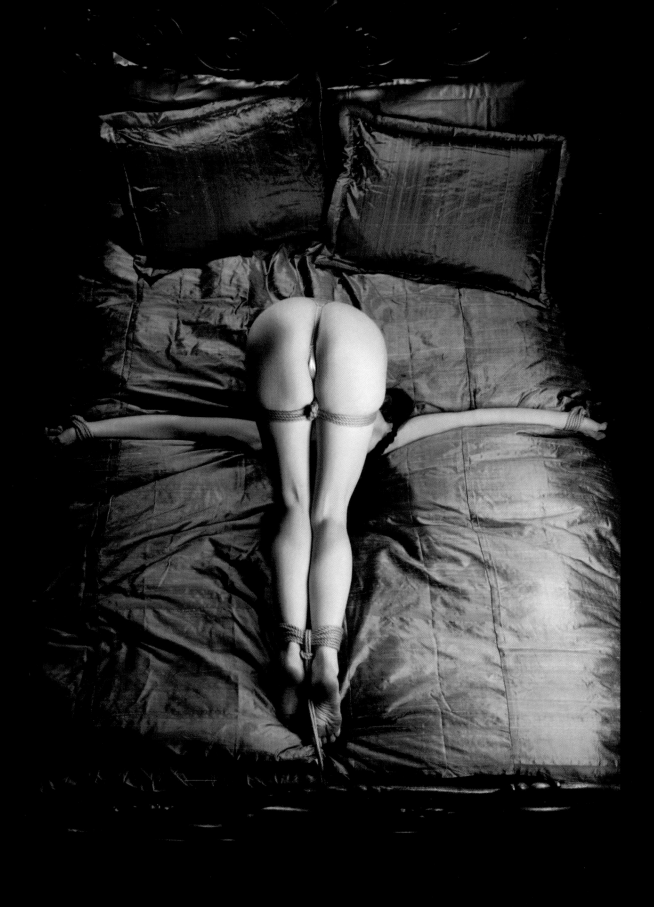

Variation: Closed Legs

I prefer closed leg style positions for sex, so this is my preference of the two Pile Driver ties. It may not be as visually pleasing but still offers many opportunities for satisfying play. It is good for spanking, ass flogging, ass worship and penetrative vaginal or anal sex. This is probably the most difficult position in the book for the bottom (along with the strapado later on). Not all rope bottoms will be able to do it, and those who can, may only be able to maintain the position for a limited time. Be sure to try the open leg tie first, as it is easier and offers more opportunity for play. Don't be discouraged, just be aware of each tie's difficulty level and each bottom's tolerance before attempting the more challenging positions. These are adventurous positions that can be very uncomfortable if done incorrectly.

1. Apply rope bondage to both wrists as with the spread-eagle and have the bottom lie on his back with his head centered on the mattress. Take each wrist tie and tie it off to the side slats of the bed.

2. Take a 25-foot rope and find the centre. Place the bottom's ankles side by side and wrap the rope around two to four times (personal preference) before looping it through. Cinch with a lark's head.

A

C

B

3. Assist the bottom in rolling up into the pile driver position and then tie the rope leftover from the ankles to the frame of the bed.

A

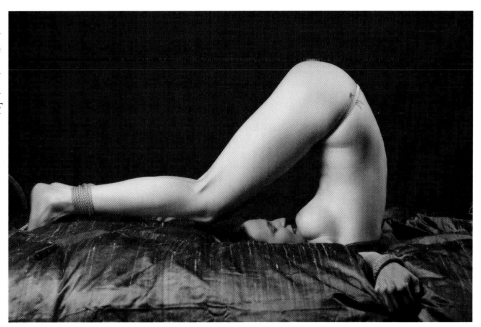

B

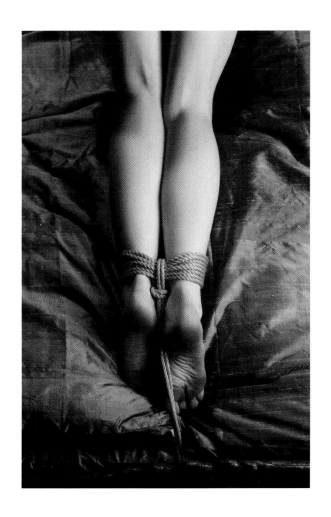

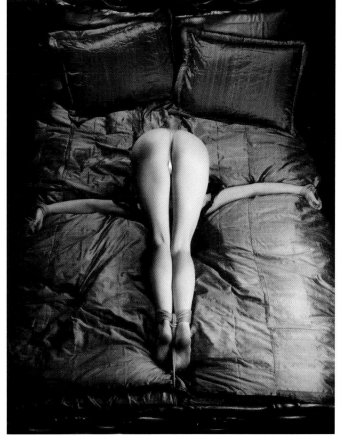

C

4. To ensure that the bottom cannot open his legs or stretch out in any way, take a 25-foot rope, find the centre and wrap it around the back of the waist and the backs of the thighs (just above the knees). Place the loop between both legs and go around again before creating reverse tension.

6. Then cinch between the knees and finish the tie with a square knot (for neatness, do this near the tummy).

5. Take the remaining rope between the legs and cinch the space between the tummy and the knees.

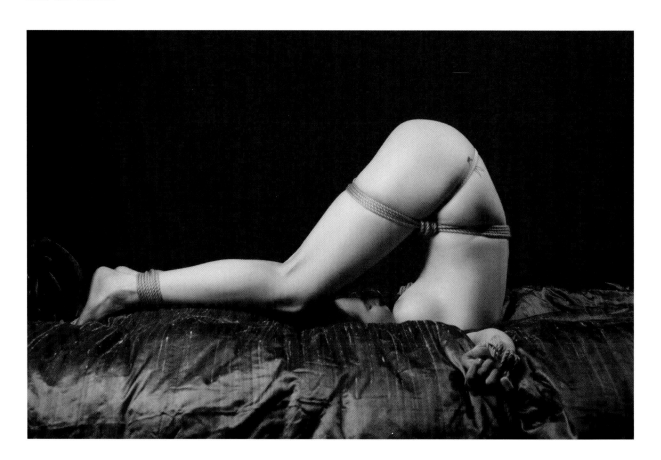

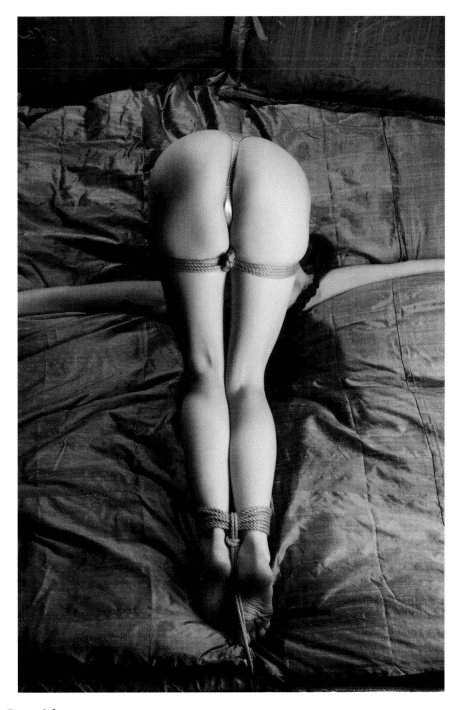

Points to Consider:

Both of the Pile Driver ties can be very dis-orientating to the bottom. Once untied, make sure the bottom does not stand up too quickly. The position really does give the feeling of being upside down and it takes a few moments to adjust when untied.

If this position does get too strenuous for extended sex play, you can just untie the legs, assist in placing the bottom on her back and keep the arms tied. The bondage is still inescapable and good for missionary sex.

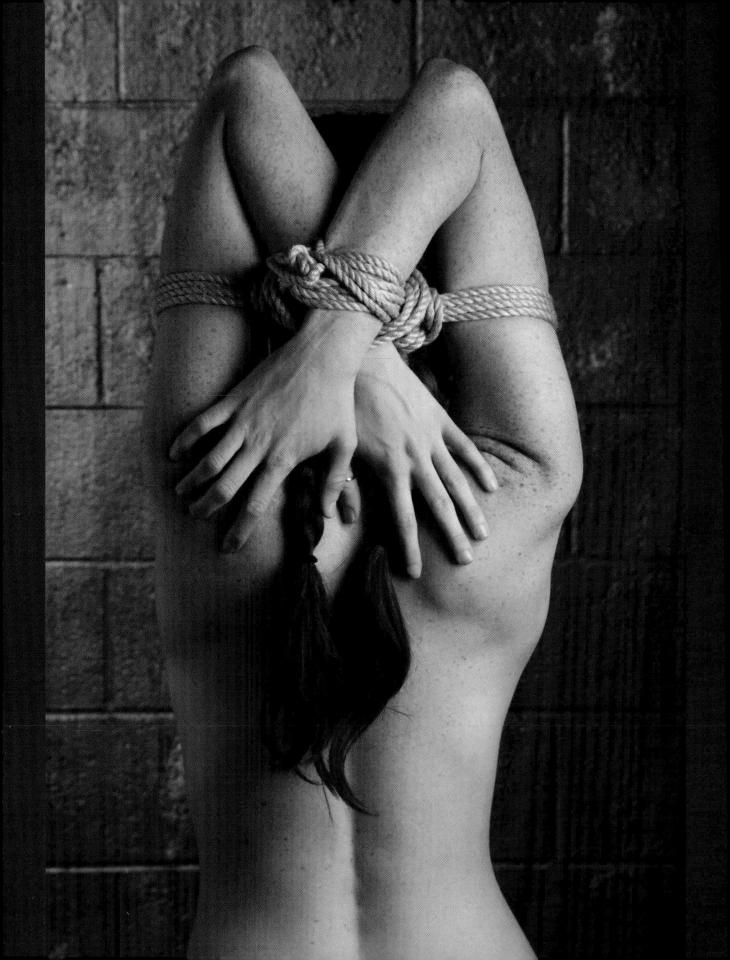

Crossed

Arm

Tie

Of all bondage ties, this is one of the most attractive. It is <u>very</u> restrictive and gives the bottom a lovely streamlined look to the tummy and chest, not to mention a complete air of helplessness.

I rarely see this tie used anywhere except on the best Internet-based bondage porn sites. I can only assume this is because many Tops are unfamiliar with it and have not tried it with a play partner. Trust me. Once you have learnt this tie, both Top and bottom will be hooked.

Remember not to limit yourself with what I display here. This arm tie will work with any number of leg ties (frogtie, cross-legged bondage, etc.), but really lends itself to missionary style sex. As with the agura, the bottom's head is being pushed forward, making for some tight, challenging bondage. The pressure is greatly relieved when the bottom lays flat on her back. And if you intend to play/fuck for an extended amount of time, I strongly recommend getting into the missionary position quickly.

If you have a bottom with long hair, have her place it out of the way with a braid or a bun/high ponytail, which you can always take out later once the tie is completed.

1. Have the bottom kneel in front of you and place her wrists in a cross behind her head (if the bottom is flexible, side by side wrists may be an option and is tied the same way). Take a longer length of rope (at least 25 feet) and find the middle. Loop the rope around the wrists only.

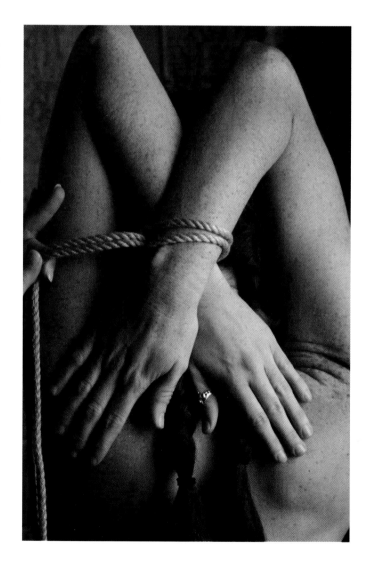

2. Create reverse tension and repeat before locking the tie off with a lark's head. At this point <u>do not</u> cinch the wrists. Take the rope around the upper arm, between the head and arms (across the nape of the neck), and back around the other upper arm. Do this with one hand while making sure the bottom's elbows stay close together with the other hand.

A

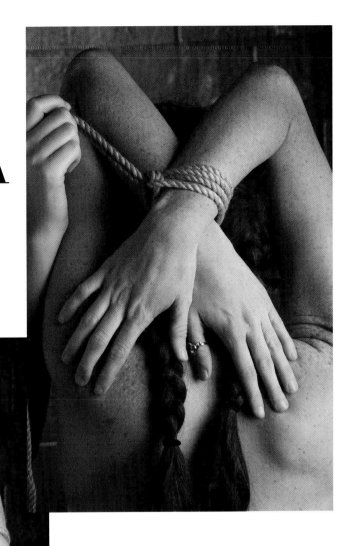

B

3. Loop through your starting point and go back around in the opposite direction and make reverse tension. At this point you have three places to cinch: between the wrists and between the neck and upper arm on each side.

4. Cinch each side of the tie first (before the wrists). Simply choose a side and cinch the front and back of the tie, then take the rope behind the neck (not back to the wrists) and do the same on the other side. If stress on the upper arm is a concern, ensure the rope cannot pull tighter by cinching with a lark's head on each side, as opposed to just looping rope around. I have displayed the lark's head technique in the photos.

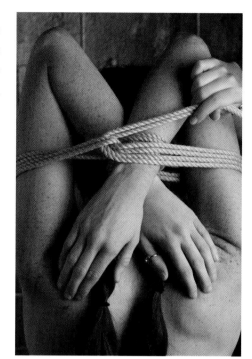

A

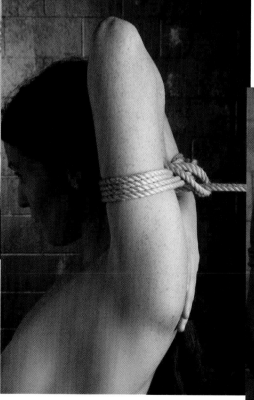

B

C

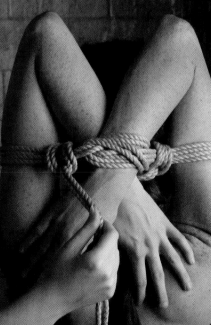

5. To finish the tie, bring the rope between the wrists, cinch and tie off (square or other knot). If you have a little extra rope to work with, you can simply bring it up towards the elbows, bring around and cinch between the two arms. If you have tied the first part of this tie sufficiently, it will be impossible for the bottom to separate the elbows further anyhow, but this makes a nice decorative touch if you have extra rope.

A

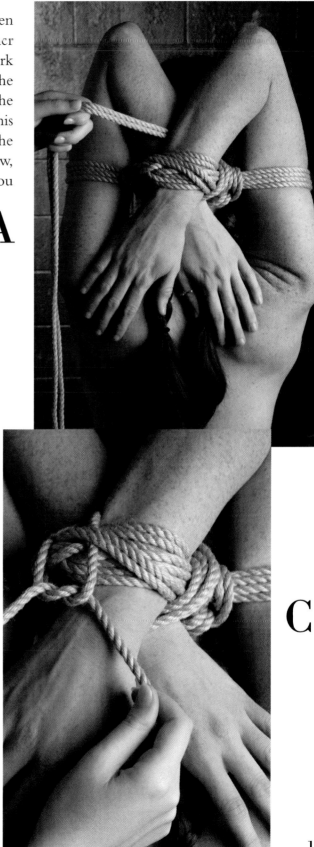

B

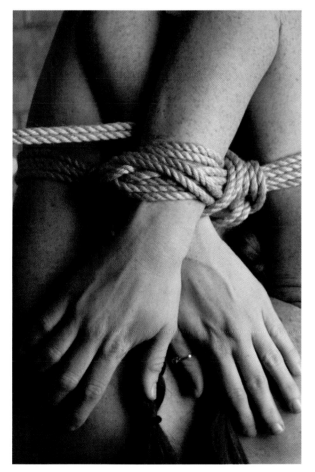

C

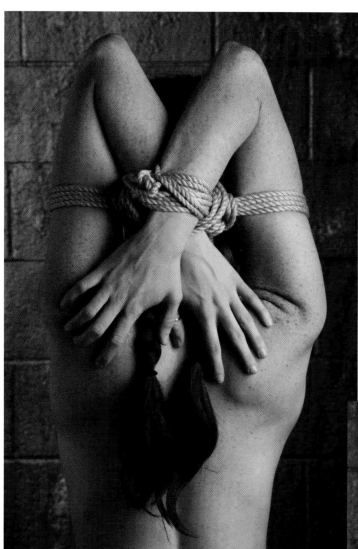

on the upper arms, numbness in the hands will occur very quickly, so when attempting the position take your time and communicate with the bottom throughout the rigging process. Remember, as soon as the bottom is lying on her back, a lot of the stress will be removed. I have demonstrated this tie with two bottoms. You can see that the model with broader shoulders is unable to have her elbows close together, but the bondage is still inescapable and strict as she cannot separate her arms any further.

Points to Consider:

It is important to keep the bottom's elbows as close as possible while rigging this position. If you don't, there is a chance that the bottom will be able to struggle and just bring the entire tie over her head untie it very easily. The idea is that the ropes around the upper arms should be tight enough to stop the bottom from being able to separate the elbows any more than you have permitted by the bondage. It may take some practice to get this tie just right. If too much pressure is placed

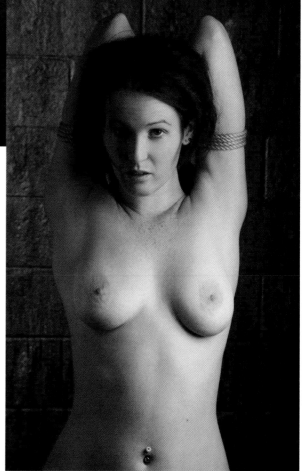

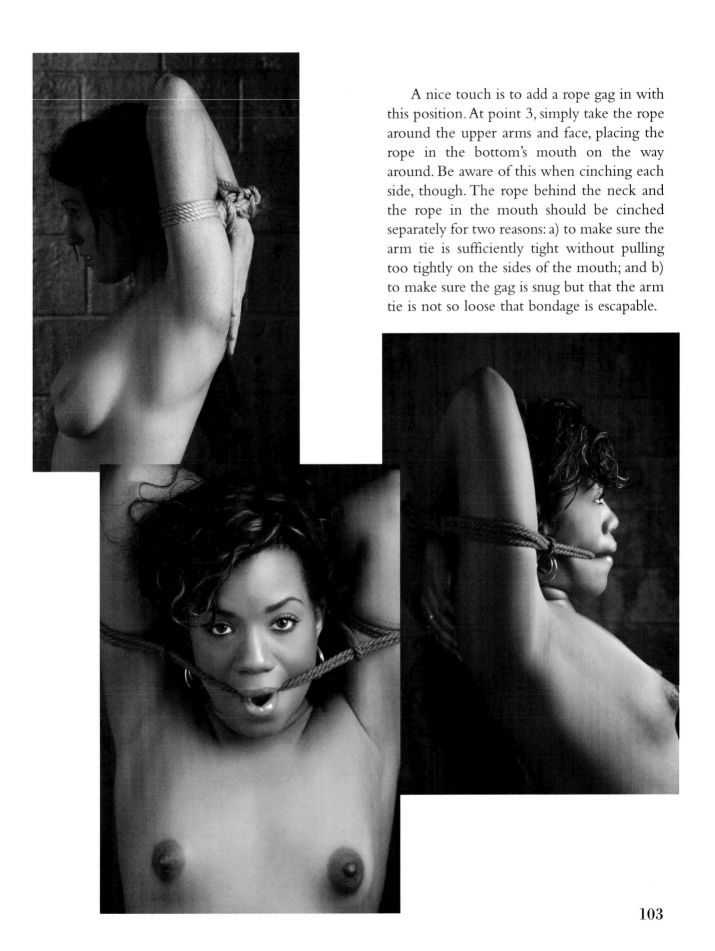

A nice touch is to add a rope gag in with this position. At point 3, simply take the rope around the upper arms and face, placing the rope in the bottom's mouth on the way around. Be aware of this when cinching each side, though. The rope behind the neck and the rope in the mouth should be cinched separately for two reasons: a) to make sure the arm tie is sufficiently tight without pulling too tightly on the sides of the mouth; and b) to make sure the gag is snug but that the arm tie is not so loose that bondage is escapable.

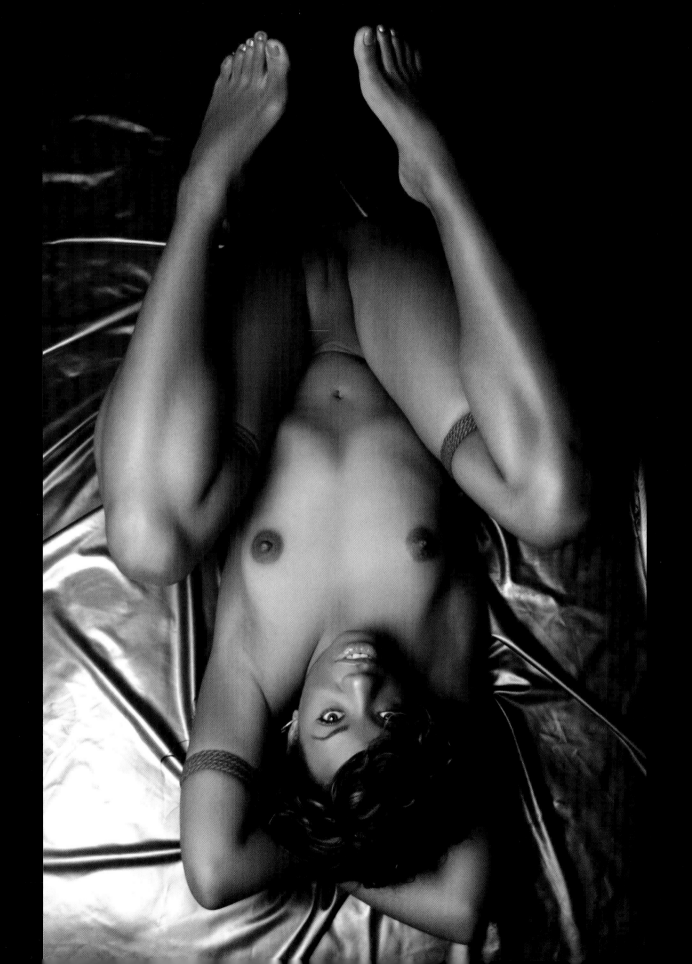

A Simple

Leg Tie

for Sex

1. Have the bottom sit on the edge of the
bed with her head between her legs. Take two
shorter lengths of rope and tie each thigh
about mid way. Make a lark's head to avoid
these ropes tightening later.

A

B

C

2. Take the remaining rope from each thigh and bring it around the bottom's back and loop through the opposite leg tie. Make sure this is nice and snug. The tighter you pull this, the further back the bottom's legs will be for sex.

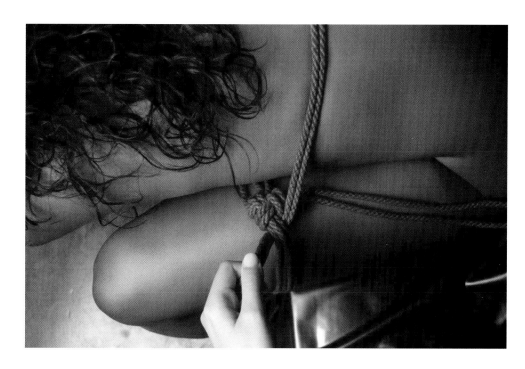

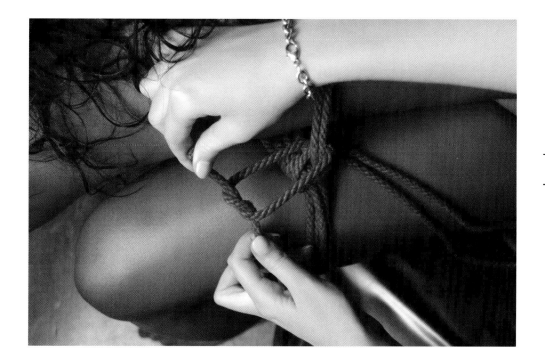

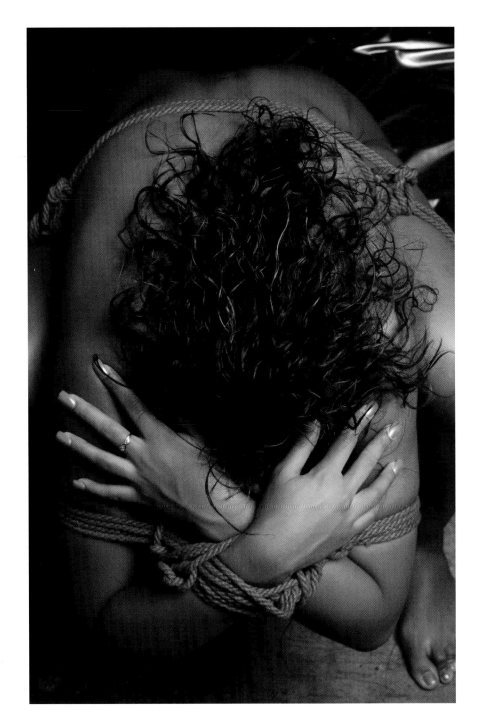

3. Return the rope to its original leg and tie off. Have the bottom roll onto her back and use the leftover rope in front of the bottom's stomach. Note: If you have done this tie fairly high on the back with legs strictly pulled back, the final step may not be necessary, as shown in the picture. Tying off on the appropriate leg completes the tie. Alternatively, you may finish by tying off at the opposite leg or with a knot in the middle of the bottom's stomach.

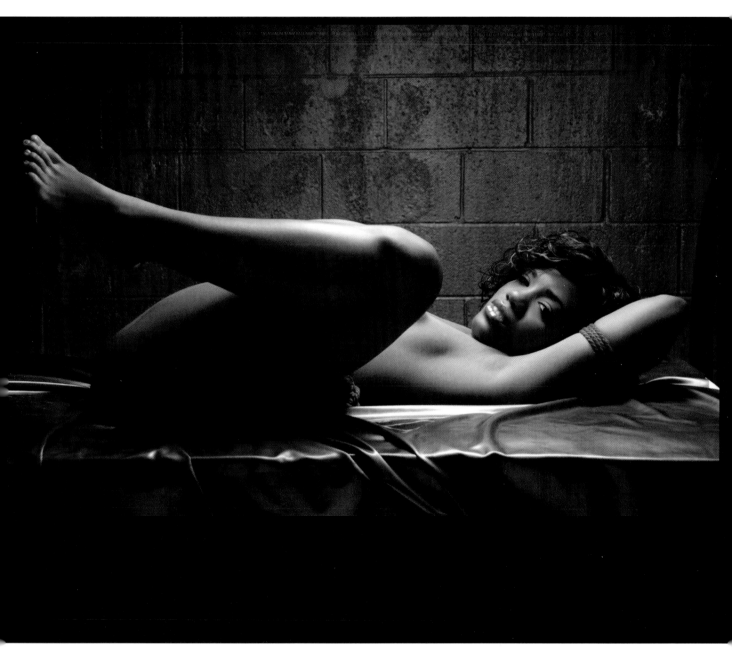

Points to Consider:

I have seen this simple leg tie done without rope in front of the stomach and be escapable. If you skip this final point your bottom may be able to roll around and release herself from the leg tie. This is most likely if your bottom is not flexible and, therefore, unable to have her legs pulled back very far. This is a personal choice you will make when tying your bottom for sex.

The reason for making sure all knots are placed at the thighs as opposed to behind the back is simply for comfort. The bottom will be able to hold the position much longer without knots pushing into her spine or back area.

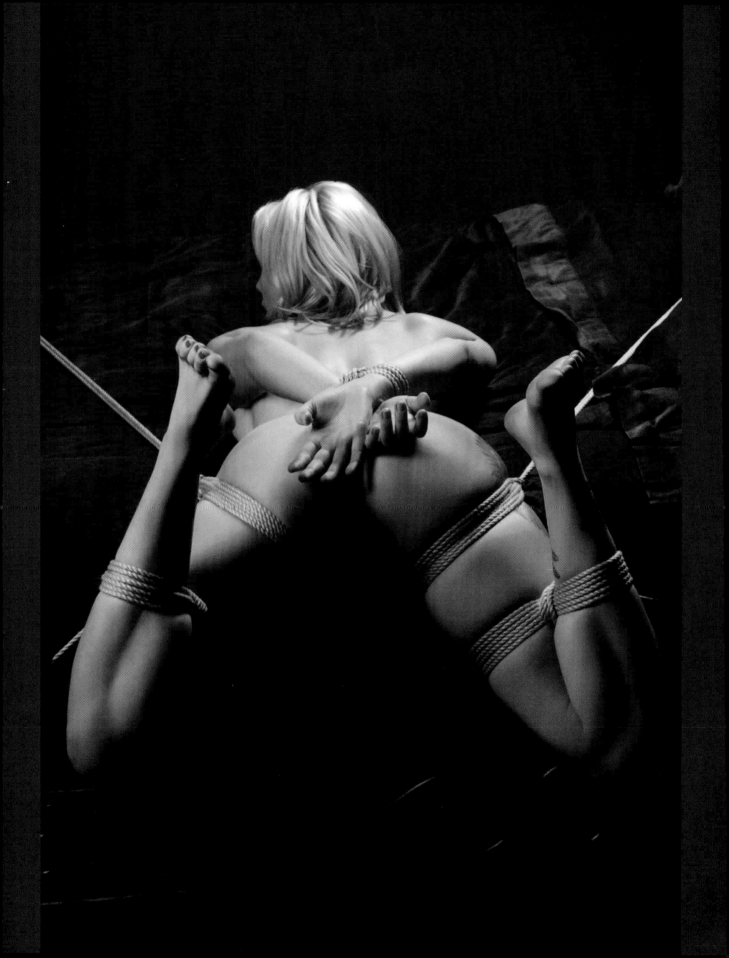

Edge
of Bed
Fuck

Obviously some of the best sex can be with a bottom bent over a piece of furniture; whether it be a bed, chair or table doesn't really matter, as long as he is bent forward with ass in the air, ready to be taken.

From the basic ties already discussed, you can see that it would be very simple to just add rope to wrists and ankles and tie these off on the object of choice to present a nice position to fuck in. Bondage is only limited by your imagination and your bottom's limits and flexibility, so try something different.

The height of your bed will affect how "fuckable" this position is for you. If you have a very low to the ground futon-style bed, you are going to give your legs one hell of a workout trying to fuck like this. It's not impossible, but it will be hugely uncomfortable for the Top. I have also used a dining room table for this position, but had to have many towels/pillows placed under my hips as the surface was so hard.

This position will give the bottom a feeling of being partially suspended while still being comfortable enough to sustain for a while.

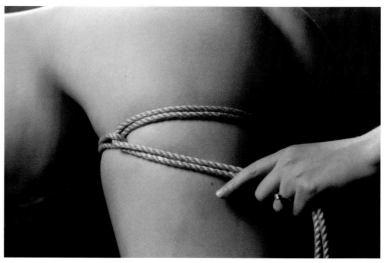

2. Loop through the starting point and make another loop under all of the layers of rope. Finish with a lark's head. Repeat on the other thigh.

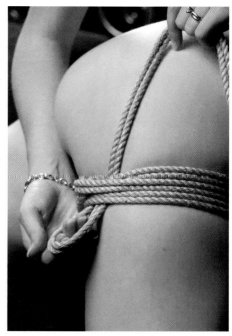

A

B

1. The thighs are going to take the bulk of the bottom's weight, so take two of your longer ropes, find the middle and wrap the rope around the upper thigh. Do this at least three times but to make the bottom even more comfortable, you may do it four or five times.

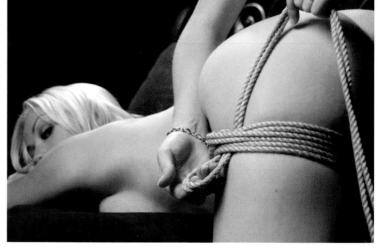

3. Have the bottom cross his wrists behind his back. Take a mid-length rope and find the middle.

Take the rope around the wrists and the waist of the bottom and bring it through the starting loop. Do the same again in the opposite direction.

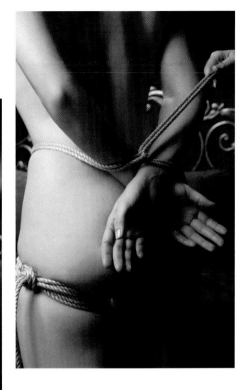

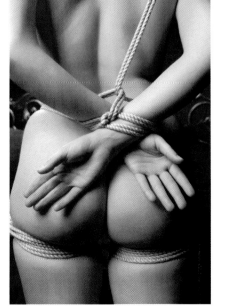

4. Bring the rope between both wrists and start to cinch the rope between the wrists and waist._

5. At this point the bondage is still escapable, so before finishing the tie you must also cinch between both wrists. This is a quick release version of a behind the back crossed wrist tie. If quick release is not an issue, you could always tie the wrists first and then tie around the waist.

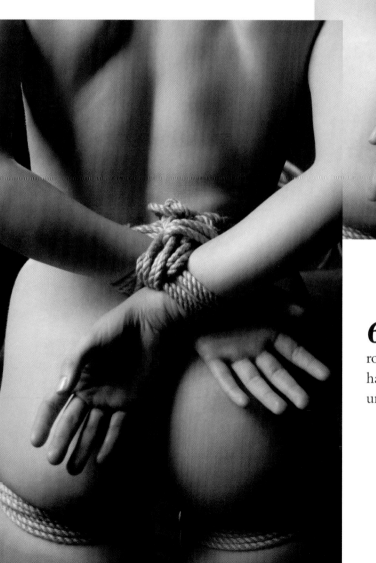

6. Tie off any remaining length of rope. Be sure to place knots above the hands, where the bottom will be unable to reach them.

7. Bend the bottom over the bed (or other furniture) and secure the thigh ropes to the object. When doing this, be sure to pull the bottom up on his toes. This rope will be taking weight and should not have any slack in it. It is also nice if both sides are even, so communicate with your bottom to ensure this. Check your knots thoroughly and, if using a slippery rope like nylon, tie even more knots than you feel are necessary, just to be safe.

8. Now it is time to lift the bottom's feet off the floor. Take one leg and do a frogtie, tying the remaining rope to the bed leg below. This is to make sure that: a) the bottom cannot close his legs; and b) the bottom cannot try to wriggle up the bed.

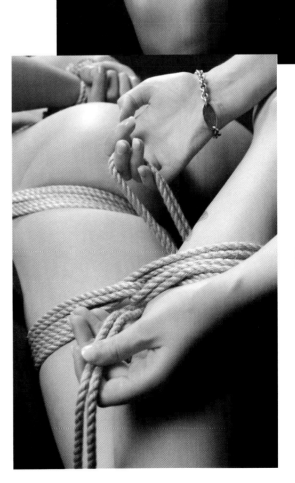

A

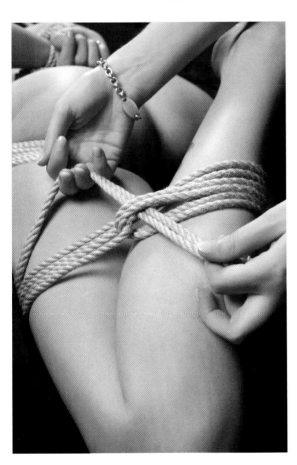

B

C

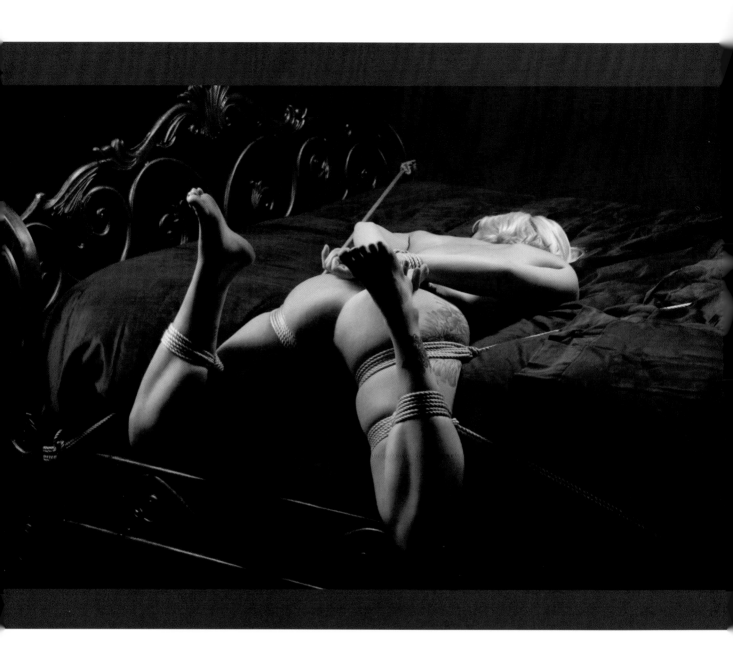

9. Repeat the same on the other leg while supporting some of the bottom's weight. When the tie is complete, gently let all of the bottom's weight fall into the bondage.

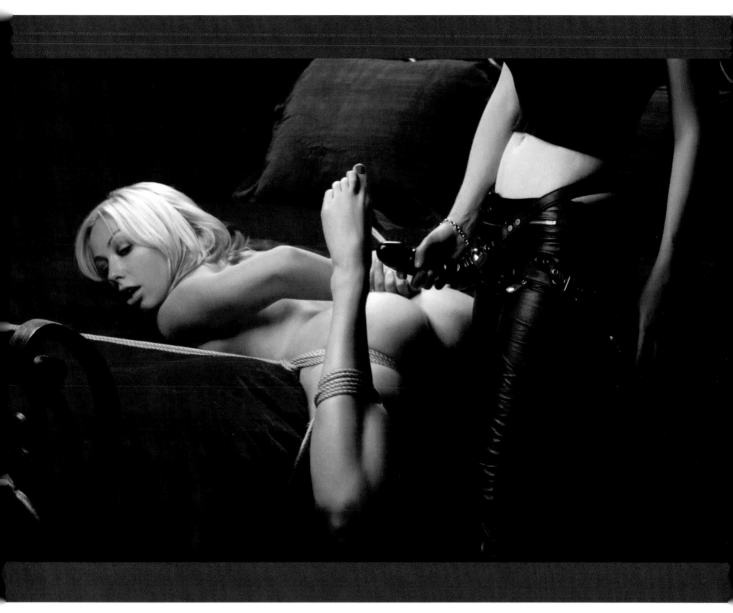

Points to Consider:

If the bottom seems to be slipping off the bed slightly, it means you haven't tied the thigh ropes to the bed adequately. It is a quick fix to tighten the slack and will make the sex all the better for it.

If you are doing this position on a hard surface like a wooden table, there will be a lot of pressure on the bottom's hip bones. As always, have small towels or pillows close by to make the position comfortable.

Don't feel limited by options in this tie. Instead of a frogtie you could tie the bottom's big toes to the waist rope and, in effect, create a "hanging hogtie." Alternatively, you could loop a rope around each big toe (or foot) and tie it off to the side of the bed to keep the feet out of the way during sex or to beautifully present them for some bastinado (beating or whipping the soles of the feet).

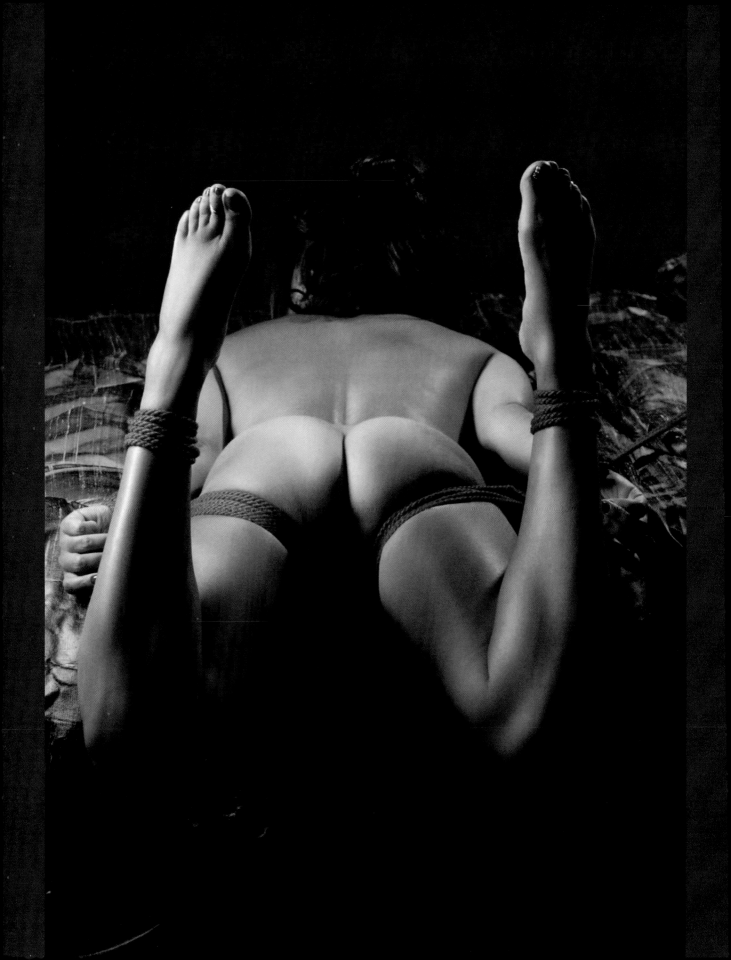

Variation: Wrists to Ankles

Another good alternative to the hands behind the back is to simply tie the wrists to the ankles. This is ideal for the less flexible bottom or if you want to play for a long time. You can choose to tie it strictly, where the wrists touch the ankles, or with more slack, like in the picture. As the wrists are pulling the legs up, you do not necessarily need to do the frogtie; you might just like to tie some rope around the leg (above the knee) and tie it down to the leg of the bed so that your bottom can't wriggle forward.

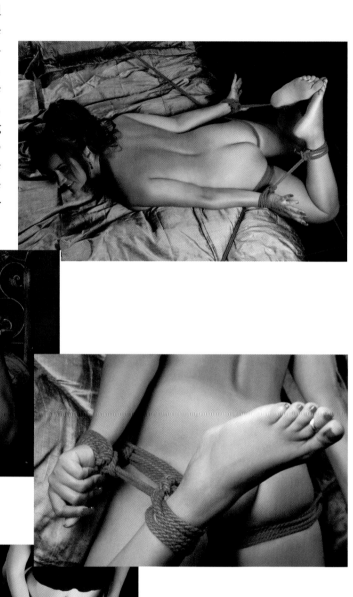

Suggestion: Strapado

This variation is definitely for the more flexible bottom. Before even attempting it, please check how your bottom would react to such a position by slowly raising her arms up behind her back in the strapado style.

1. Tie the bottom's wrists together behind her back with a short rope.

2. Take another rope and make a lark's head around the existing tie between the wrists.

3. The remaining rope will now be used to pull the arms back into a strapado. Tie the rope off to keep the bottom positioned this way. This is best done with a headboard, but the border of the bed frame will also work.

4. This tie is effective as it is, but on a very flexible bottom you can also tie the elbows together.

Points to Consider:
Remember the hands are raised in this position, and gravity is not on blood circulation's side. Keep a close eye on the bottom's hands throughout, as numbness is usually a question of when, not if, with any bondage where the bottom's hands are above the head. This position will also bury the bottom's head into the bed, making breathing difficult. If possible, have the bottom turn her head to the side. If you use a harness gag or hair tie, you will be able to pull the bottom's head back, but this is a very strict addition to the tie. This bondage position should only be used on a bottom that is: a) flexible; and b) likes to be absolutely restrained so that she has no movement whatsoever. This is NOT for everyone and is close to an advanced tie.

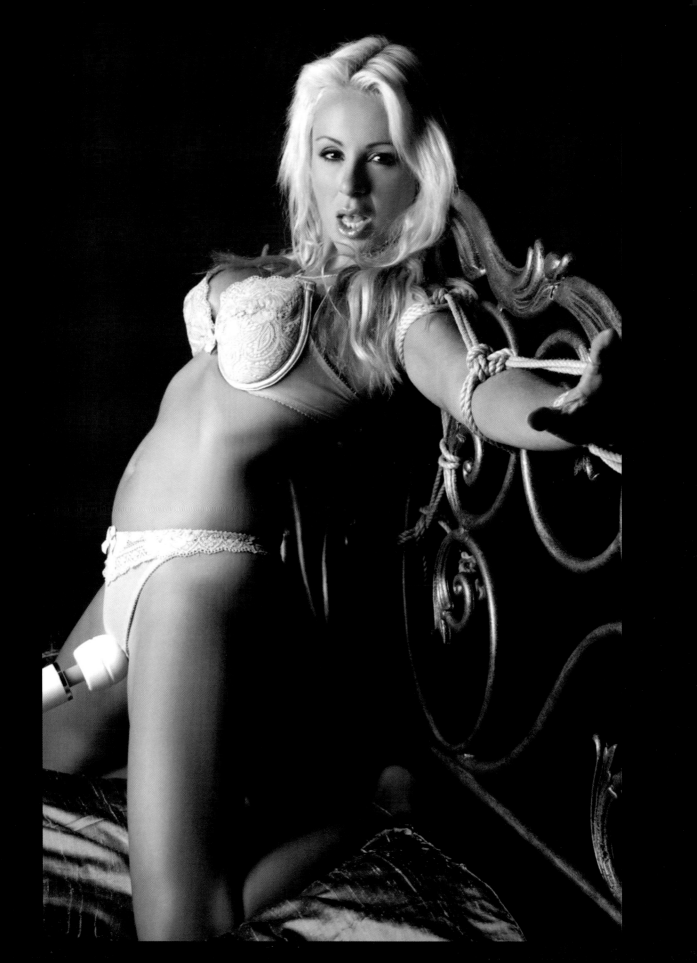

Don't waste that

Headboard
or
Footboard

Many positions in this book require no tie points at all. Some use only the corners of the bed, which may be bed legs or, in some cases, wheels, and I have occasionally referred to the slats under the mattress. I wanted to assume that the majority of readers may have beds with few or no tie points and still be able to demonstrate good restrictive bondage that could be performed at home on the comfort of whatever is available.

Readers who have invested in a bed that offers more tie points, such as a canopy, really do have unlimited options when it comes to bondage, but a great middle ground is a bed with a headboard and/or a footboard that you can tie to.

Here are a couple of basic ideas for sex bondage positions that make use of the additional tie points on a bed.

Bound for Oral Sex:

In this strict arm tie, you do not need to tie the legs. The bottom may be able to wriggle around but will not be able to stand. It is ideal for forced oral sex. On a female sub you could be nice and have a magic wand on the clit (use a microphone stand to keep it in place). If your sub needs a little encouragement to do a better job pleasing you, stick a remote controlled electrode in her butt and let the games begin.

1. Have the bottom kneel in a crucified position with the arms parallel to the height of the tie points on the head/footboard. Take a 25-foot rope and find the middle.

2. Make a lark's head around the side of the headboard and then take the rope to just above the wrist. Loop around the lower arm and furniture twice before creating reverse tension

A

B

C

3. Cinch the wrist tie with a lark's head. Take the remaining rope to just below the elbow and do the same again.

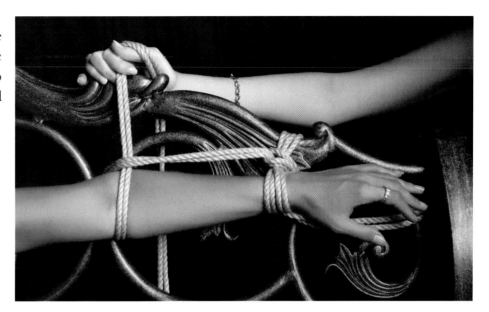

A

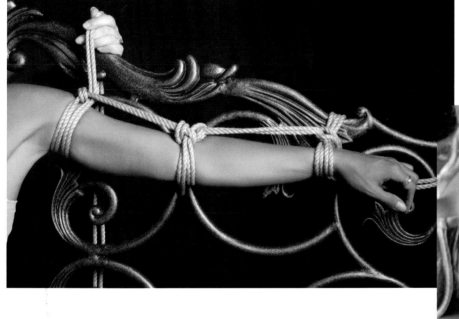

4. Now take the last of the rope to the upper arm and complete the tie. You may or may not choose to cinch the rope on the upper arm. If you tend to tie a little too tight, I would advise not to cinch this part of the tie.

B

5. Make sure the bondage is tied off behind the furniture where the bottom's mouth cannot get to the knot. Now do the same on the other side.

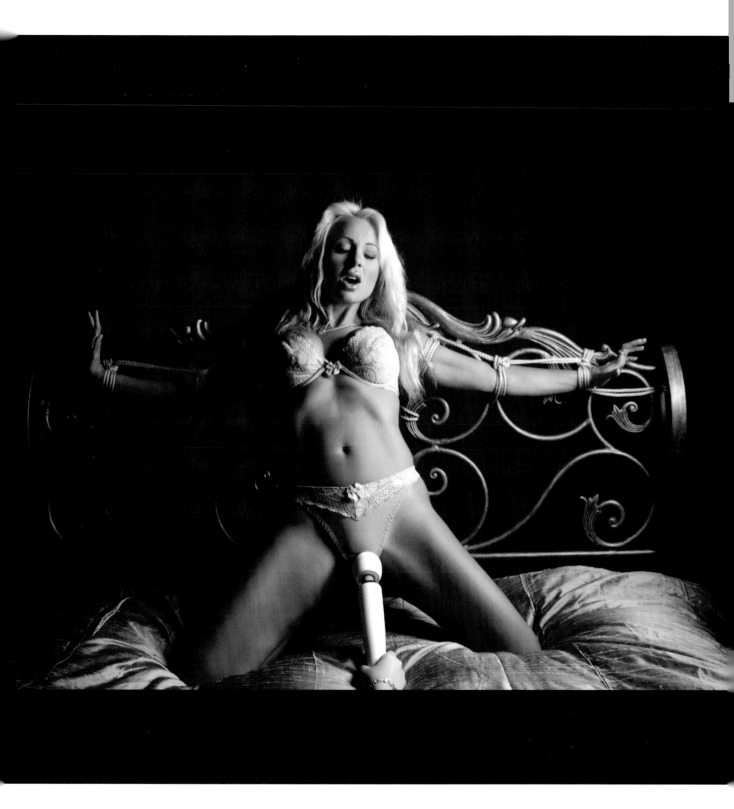

Points to Consider:

If you don't have furniture that offers tie points like this, you can just use a bamboo pole, which is widely available at most hardware and garden stores.

A perfectly comfortable missionary fuck:

A headboard offers the chance to tie legs back for missionary sex while not being as strict as when you have to tie them all the way back to the legs. This is one of the few positions where I think it's nice to have the bottom's hands tied in front for extra comfort, but you can tie them any way you wish.

1. Tie each ankle as per the spread-eagle position. If you are feeling nice, use the foot harness variation.

2. Tie each ankle to the corresponding corner of the headboard.

3. Have the bottom place her hands palm to palm in her lap and tie the wrists together.

4. To limit movement, take any left-over rope and tie it around the bottom's waist so that hands cannot move from where you have placed them.

Doggy Luxury:

If you do have tie points that are above the hip height of your bottom when in doggy position, then make use of them. This will be the case with a canopy bed or with a bed that has both an equal height head and footboard. Rig some rope around the bottom's upper thighs and tie off to each point. This will make sure your bottom cannot lower the height of her orifices or try to roll to the side.

The Calm Down

At the conclusion of an aerobics class or any type of workout activity, there will be a cool down. As sex and bondage are both strenuous and active, it makes perfect sense for the same principle to be applied to bondage/sex play.

In sex bondage I usually find the scene naturally ends when both parties have climaxed (perhaps more than once!), but this is not always the case. Some bottoms like to wallow in their bondage long after the sex is over and just enjoy the feeling of the rope on their skin. It is a delightful feeling to have experienced strong orgasms while in strict bondage and then be able to just lie in the rope a little longer.

Common sense and communication will determine when a scene comes to its natural end. In my experience, most scenes detour from the original "plan" (if there was one) and can change into something completely different and even more exciting. That is the nature of rope bondage. As a Top, you may have a position in mind but then, during the play, the bottom will bend a different way and reveal an entirely new position to you which you simply must rig immediately.

A scene may end unexpectedly because of a loss of circulation, a leg cramp or any number of other reasons. If the bottom needs to be released for fear of injury or because he uses his safe word, the bondage must be immediately removed and any problems must be communicated. In some play I have seen, the Top has become irritated at this. That is not okay and is certainly the quickest way to ensure the bottom will not play with you again. Both Top and bottom get excited when playing, and when a scene is cut short it is equally disappointing. There is no room for selfishness in this situation. Instead, embrace the situation as a chance to display the mutual trust and respect you have for each other.

Once it has been determined that the play has come to its conclusion, the Top will begin to remove the rope. This can be a sensual activity in itself, but not all bottoms like the same thing. Be sure to check. Personally, when I am ready to be untied, I am really ready and I want the rope removed quickly. For others, it may be an enjoyable experience to have rope slowly removed and pulled over erogenous parts of the body. This decision may also be determined by whether there is any loss of circulation. If there is, the ropes must be removed in a timely manner to allow blood flow to the limb to return.

As a Top, it is easy to want to untie your bound beauty at lightning speed, especially if she has been tied for quite some time. But you must be aware of rope burn. Hemp, nylon and cotton all have a "burn speed," and all feel as if you have just been dragged across

carpet when you encounter it! Certainly remove ropes quickly if necessary, but don't just rip rope as fast as you can from under the bottom's arms, etc., or the bottom will be left with actual burns that will need first aid treatment.

After the adrenaline rush of bondage and sex, the body can feel physically exhausted for both the Top and bottom. In the "Before you Begin" chapter, I provided a list of items that you should have on hand throughout the scene. It is now that most of these will come in handy. Both parties should replenish their bodies with water or other fluids. I don't recommend high sugar soda at this point, as you are trying to replenish and hydrate your body. Personally, I enjoy a warm cup of tea. Small snacks also come in handy. Fruit, saltines, biscuits and sandwiches are all good choices to help boost the body's energy levels should you need to continue on with your day.

After such a rush, it is easy for the body to rapidly change temperature, so make sure a blanket or coat is close by. Don't let the bottom move too quickly or before his body is ready. Standing up too quickly could result in dizziness and possibly even fainting. It is important, if you are playing within a set amount of time, to set aside the time needed to "calm down" afterwards.

I wrote this book assuming most readers would use it in their sex lives at home, on their beds. Of course, if that is the case with you, as it usually is with me, I really enjoy the luxury of being untied, drinking some hot tea, cuddling with my partner and simply falling into the deepest, most blissful sleep. If you have this option, I urge you to take it. If not, the steps I have listed above are merely a guide. Every Top and every bottom is different, and all have different needs after a scene. For both to be able to walk away with a sense of satisfaction, the needs of both must be addressed. There is a time for silent reflection, but also a time to talk about the bondage and sex and the way each party felt during and afterwards. If the time to talk is not immediately after bondage sex, then be sure to follow up a day or two later.

In the Event of Injury:

Should an injury occur, or even be suspected, it should be dealt with immediately. Rope burn and loss of circulation are probably the most common minor injuries associated with bondage, but when left unnoticed during play these can quickly turn into open wounds or nerve damage. I am not trying to scare you, and certainly don't want you to overreact, but just be aware. It is so easy to get lost in the moment (both Top and bottom) and not notice that a hand is cold and turning a dark purple shade. You may even notice it but be so consumed with passion that you say to yourself, "Oh, it'll be alright." You might be lucky and that may be the case, but as someone who lost the entire use of my right hand for eight weeks as a result of careless rigging and bad communication on my part (I didn't safe-word; I told myself it would be alright), I cannot emphasize the seriousness of nerve damage enough. There is a very distinct kind of pain that warns you against such an injury. If the pain does not feel "good," if there are shooting pains or pain caused by bad placement of a knot that is excruciating, please don't tolerate it. Your body is telling you that something is seriously wrong and the problem must be addressed. Those experienced in bondage and S&M play may say pain can feel good and I agree, but when the pain feels "bad," it is time to stop playing and be swiftly untied.

In the event of losing circulation, untie the limb and place it below the bottom's heart. Be patient. There may be some feelings of pins and needles but this is normal. It may help to even rest the limb in a bowl of warm water, therefore encouraging circulation. If there is no feeling of pins and needles returning to the limb, there may be nerve damage. Don't become stressed, be patient. Sometimes it can take time for full use and feeling to be restored. Do not overreact to a cold hand or some slight discoloration. Simply communicate with your bottom about it to see if there is a problem. If the pain is "good" and the bottom still has full use of the limb, there may not be a problem at all.

Should the unthinkable happen and nerve damage has occurred, consult your GP. You will be most likely be advised to wear a brace and rest the limb for any number of

days or weeks. You may also be referred to a neurologist. Some people say that acupuncture and massage can help heal nerve damage, but I found no medical information to back up these claims. If it will make you, as an individual, feel better to explore alternative methods then by all means do so. The fact is nerve damage takes time to heal. Do not expect overnight results.

Remember, any type of bondage play is a "team" effort. As a bottom, it is your responsibility to understand that you can use your safe word when needed and to not ignore warning signs that your body may be giving you. As a Top, you must constantly check in with the bottom and monitor limbs that are bound for temperature and color change. Keep these basic rules in mind and you'll have very rewarding bondage sex many times over.

The End

Congratulations! You are now well on the way to enhancing your sex life with the beauty of bondage. I guarantee you, it's going to be a wild ride and a journey on which you will never stop learning.

I have provided a basic-intermediate guide. None of the positions are set in stone. Some positions may work for some people and not for others. Some of you will fall in love with the craft and want to learn more. There are limited books available that are "how-to" guides for bondage, but once you know the basics you will find that you will become your own teacher. Many major cities also hold bondage (and other BDSM activity) classes at local dungeons, community play spaces and kinky stores. Do a Google search and you'll be amazed by how many like-minded people you find. If you have an interest in bondage but prefer to keep it private, that's fine, too. Experiment with your partner in the comfort of your home. There are multiple resources online that can help without you ever having to go to a dungeon.

As for the "rules" of bondage, there are no hard rules for the bondage itself, but rather just common sense. If you like fancy knots, then by all means tie them. If you just love to have your bottom in a hogtie, then try every variation you can think of. And if you just want to bind feet, go ahead and do it. Just because it is not in this book does not mean it isn't possible or shouldn't be tried. Keep it safe, keep it sane, keep it consensual and have a great time!

Take care,

Chanta
www.bondageexpert.com

Resources

have a calendar feature. Chanta Rose, Jay Wiseman and Midori are all San Francisco-based educators who travel to teach bondage and other subjects.

Books:

The New Topping Book by Dossie Easton and Janet W. Hardy

The New Bottoming Book by Janet W. Hardy and Dossie Easton

Jay Wiseman's Erotic Bondage Handbook by Jay Wiseman

The Seductive Art of Japanese Bondage by Midori, Craig Morey (photographer)

All books are available from the publisher and www.amazon.com .

Toys and Rope:

Depending on where you are based, you may be able to find very good stores locally. London and San Francisco have these in abundance. If not available where you are, venture online.

www.extremerestraints.com offers a huge selection.

www.jtstockroom.com has some great leather restraints.

www.twistedmonk.com – The best hemp rope around.

www.rainbowrope.com – A great place for all colors of nylon rope.

www.agentsm.com sells upscale sex toys and lovely silk bondage scarves.

Educators:

Many educators travel the world teaching everywhere from community play spaces to sex stores to private homes. Search for local organizations and then check their sites for schedules of upcoming events. Many sites will

More About Chanta:

www.bondageforsexguide.com – For more about this book.

www.bondageexpert.com – Chanta's schedule and other information.

www.bondagepussycat.com – Chanta all tied up!

www.chantasbitches.com – Chanta doing what she does best: Sexual Domination!

www.bdsmpress.net – The publishing company Chanta is signed with.

Searching Online:

Chanta has provided limited links due to the nature of constant change on the World Wide Web. She recommends using the following search terms on Google to assist in finding more information:

"BDSM" will link to many articles and definitions of the term.

"Beginner BDSM" will display sites that assist in the introduction of BDSM.

"BDSM organization (city name)" will display local sites, chat rooms and organizations within the BDSM community.

About
the Author:

Chanta Rose is best known for her work as a glamour model in the United Kingdom, a bondage model in the United States and as past rigger/director/webmaster for three of the largest bondage-oriented adult sites in the world (wiredpussy.com, waterbondage.com and menin-pain.com). Her love of bondage, in particular bondage/S&M and fetish sex, is shown in the years of shoots she has directed and the countless number of models (both male and female) whom she has introduced to the joys of erotically exchanging power.

Now based in San Francisco, Chanta finds herself busy teaching classes on bondage for sex, electro play, suspension bondage, bondage photography and any other kinky subject she can think of all over the country.

Chanta hopes to continue to educate anyone interested in exploring BDSM and to assist in breaking down the barriers sometimes associated with consensual power play and pornography. She also has plans to return to directing. To check Chanta's schedule, read her blog and see other examples of her work, go to: www.bondageexpert.com.

I would like to thank all of the models that volunteered their time to make this book happen:

Mika Tan and Alec Knight
Seven (aka Adrianna Nicole)
Sydnee Capri
Darling and Blaze
Jessica Sexin
Stacy Burke
Moe
Sirena Scott

About the Photographer:

Ian Rath needs little introduction. He is known and respected within both the BDSM community and the bondage/fetish adult industry.

Ian grew up in Southern California and has been tying women up ever since high school! His love for photography turned into a commercial career, which he pursued for 20 years before "accidentally" moving into fetish and bondage. At that time the bondage photography available was amateur at best. Ian took his natural talent and applied it to photographing women in bondage. The result was FetishNation.com.

Launched in 1999, Fetish Nation has become one of the leading bondage and fetish sites on the World Wide Web.